Studies in Mixed Media

Figures and Designs for the Month of July 2013, by Benjamin Long

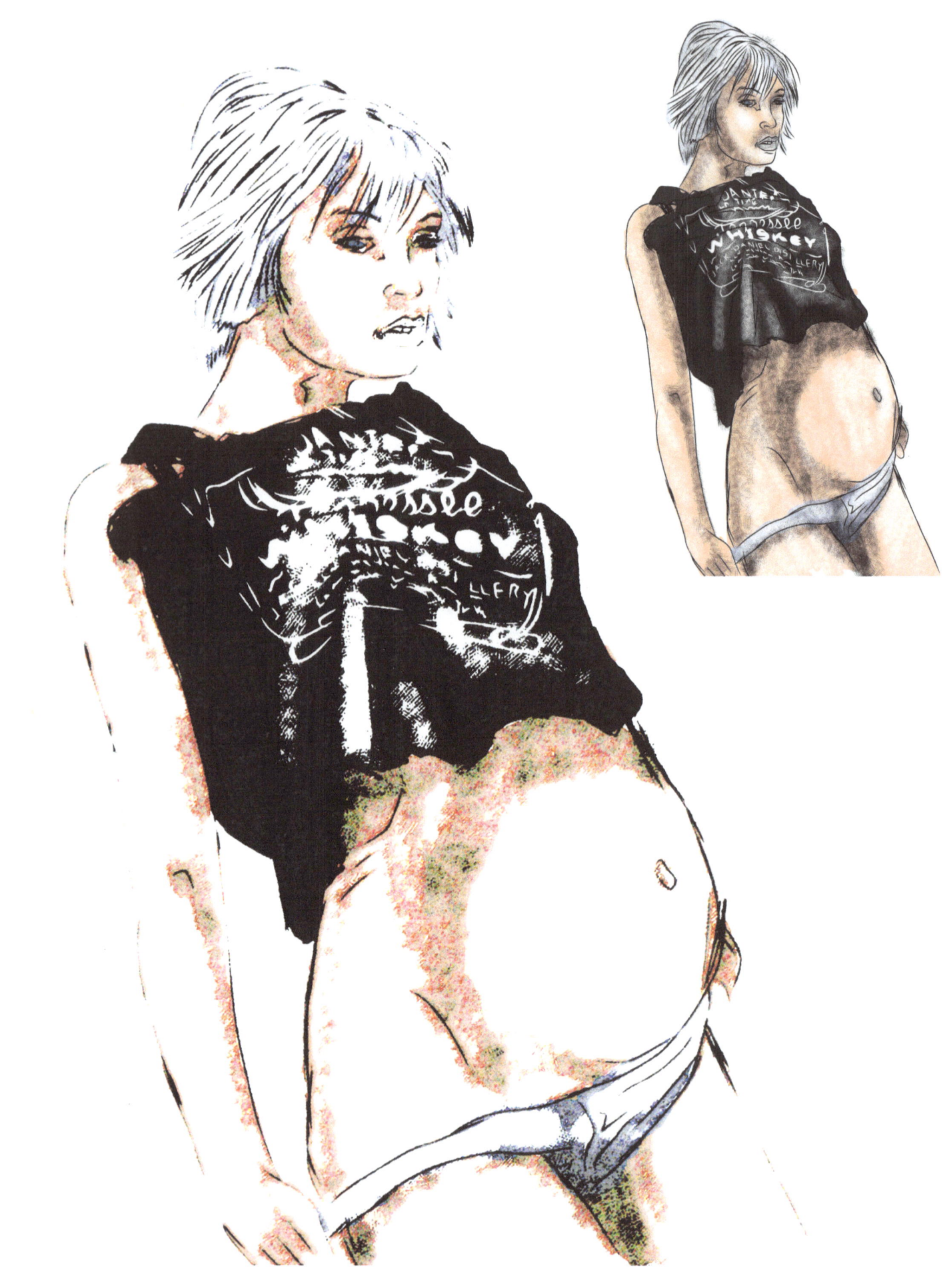

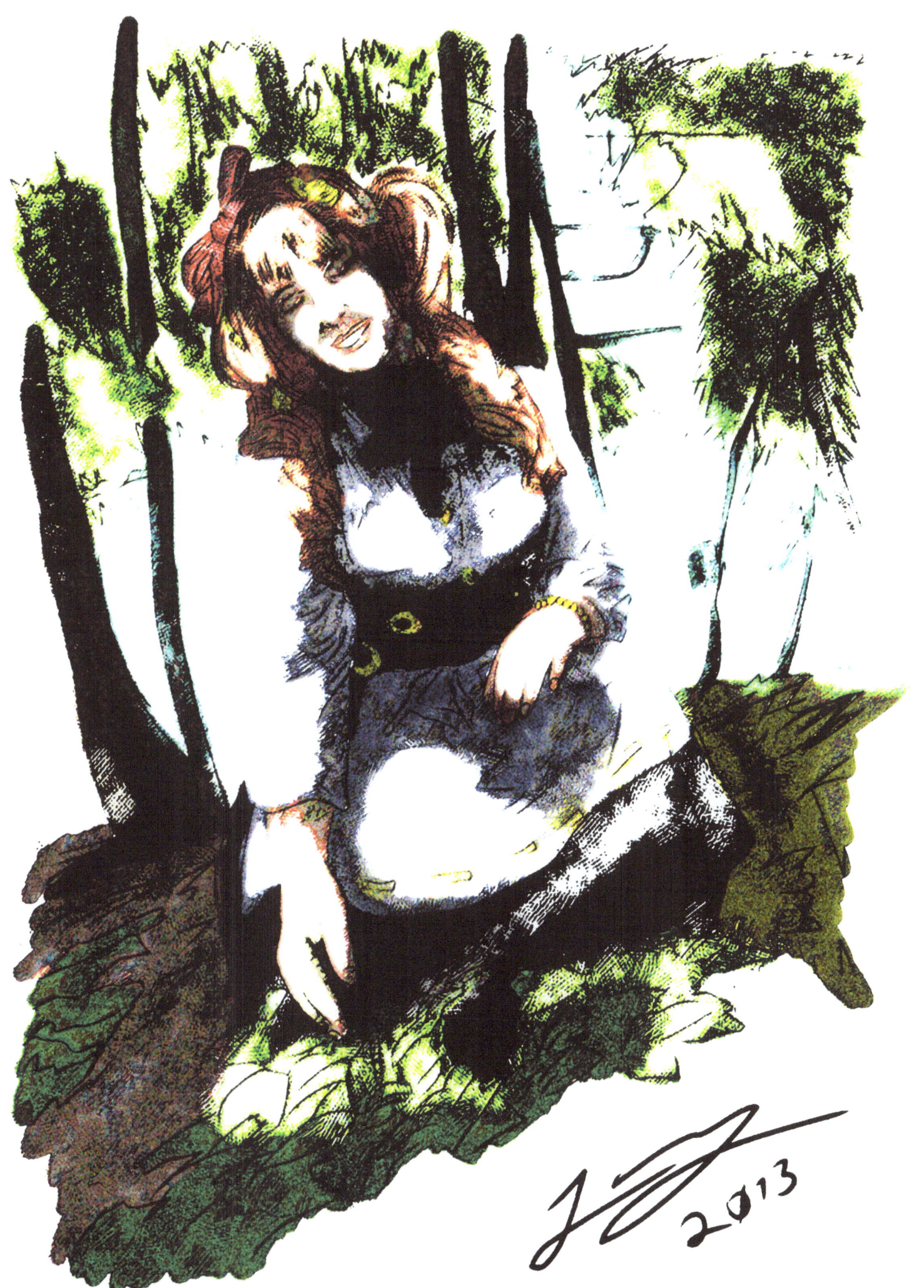

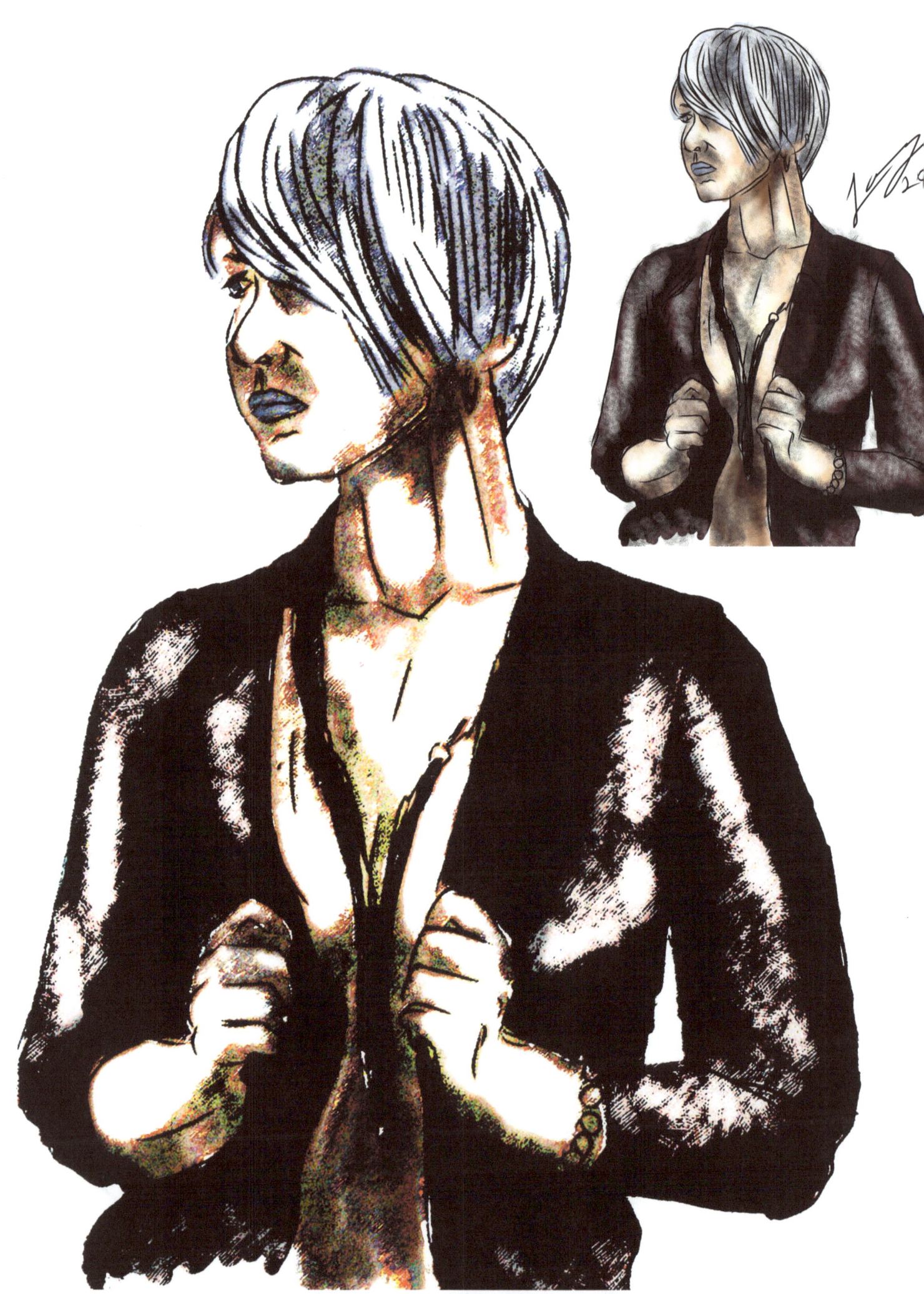

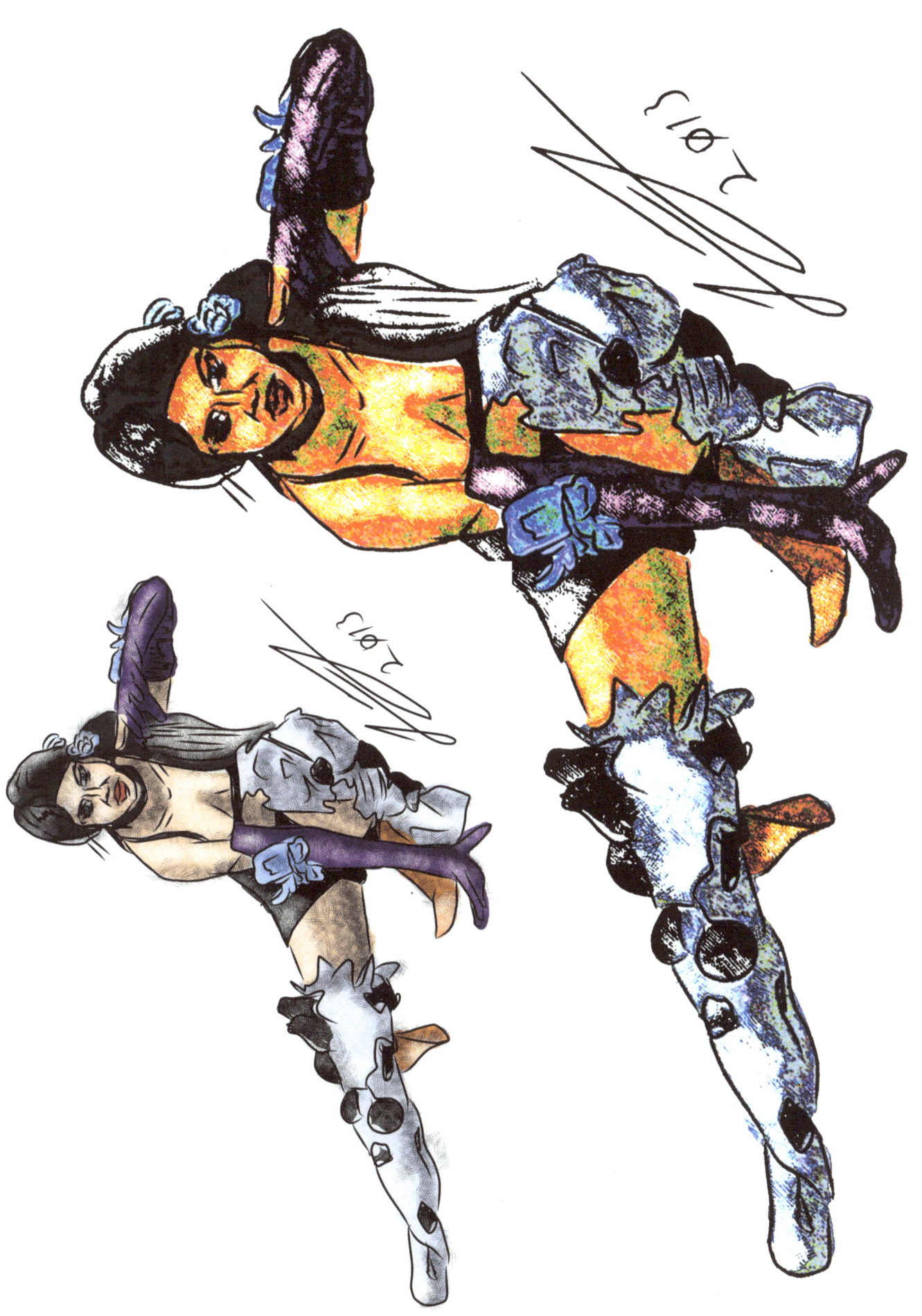

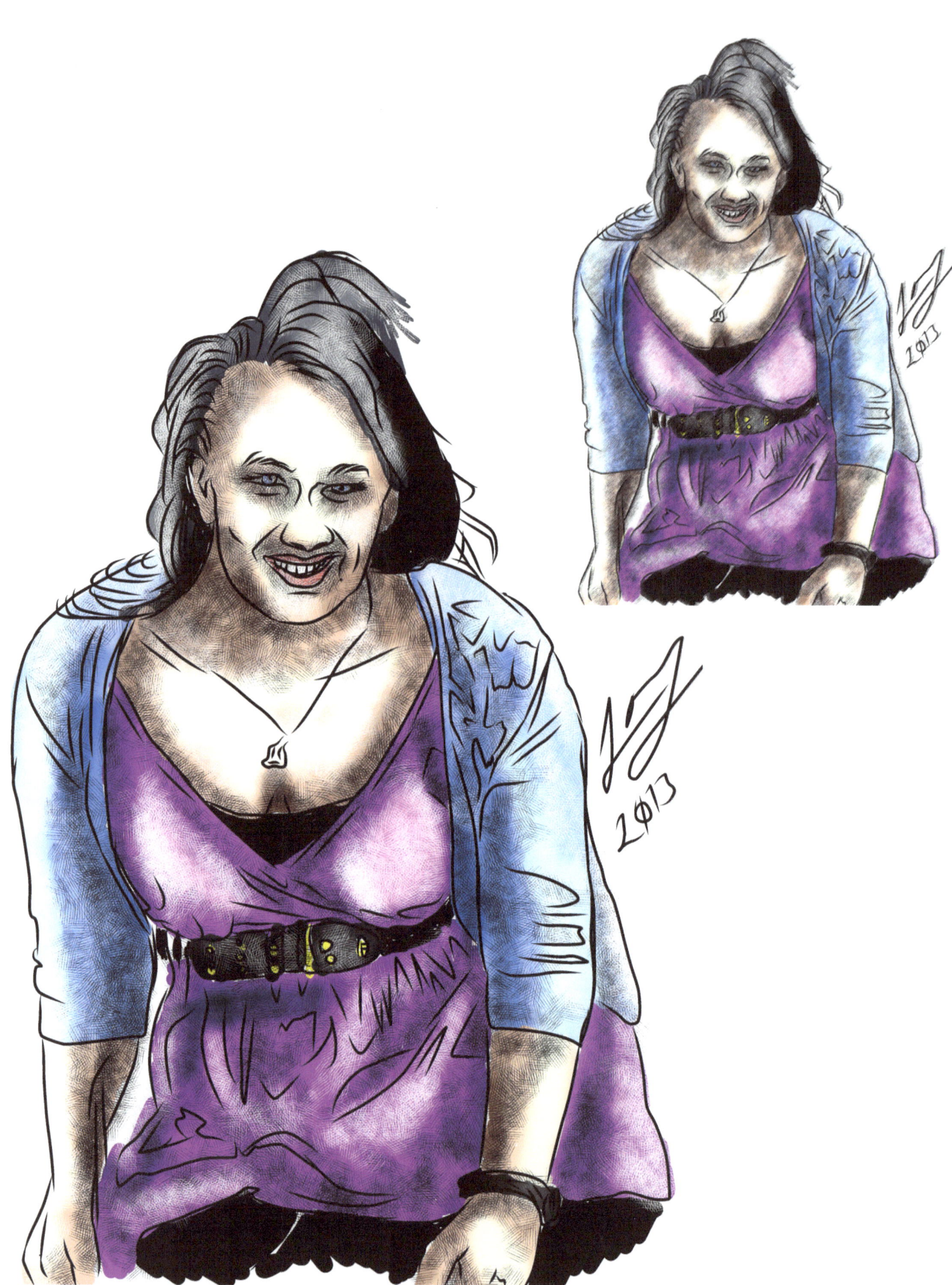

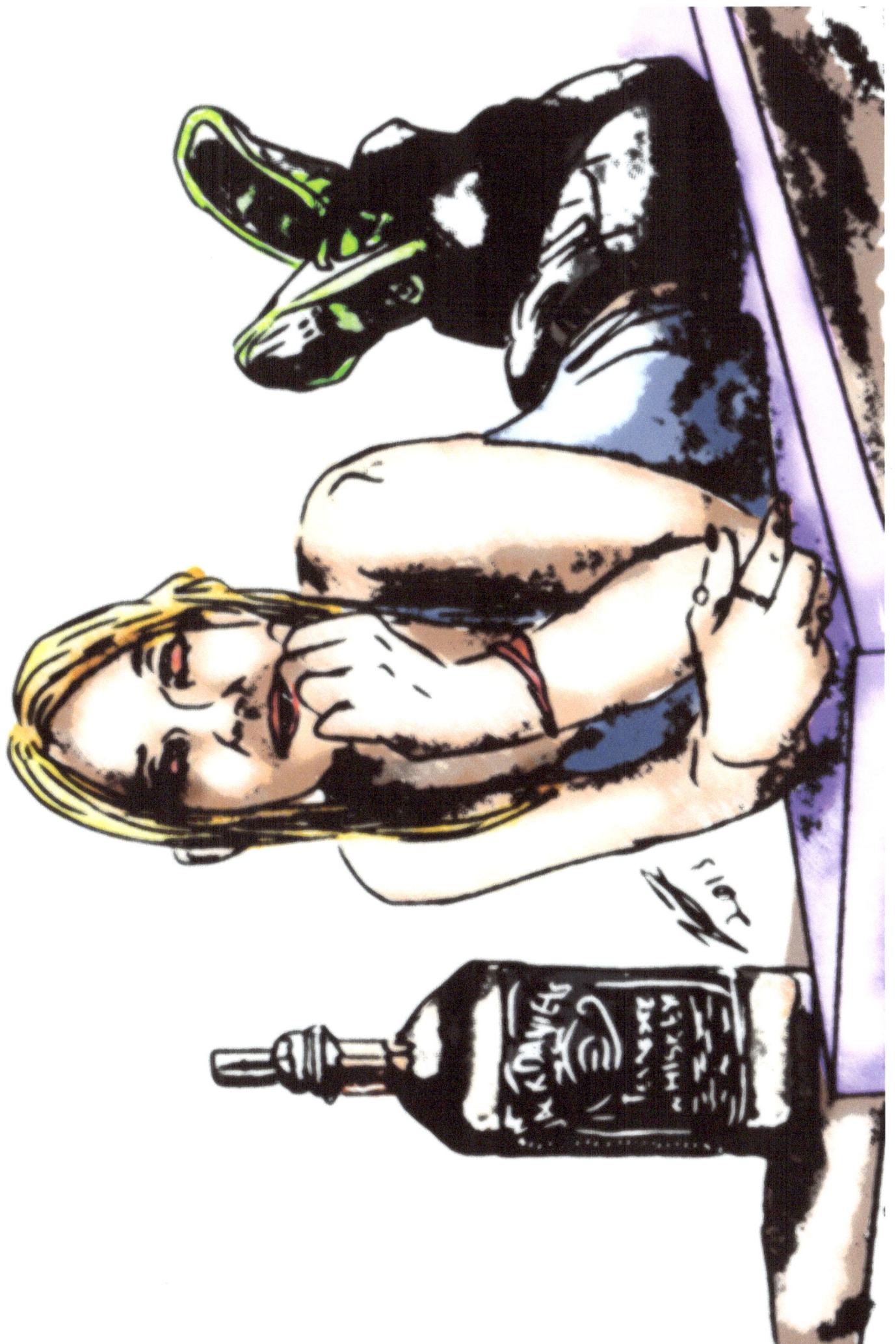

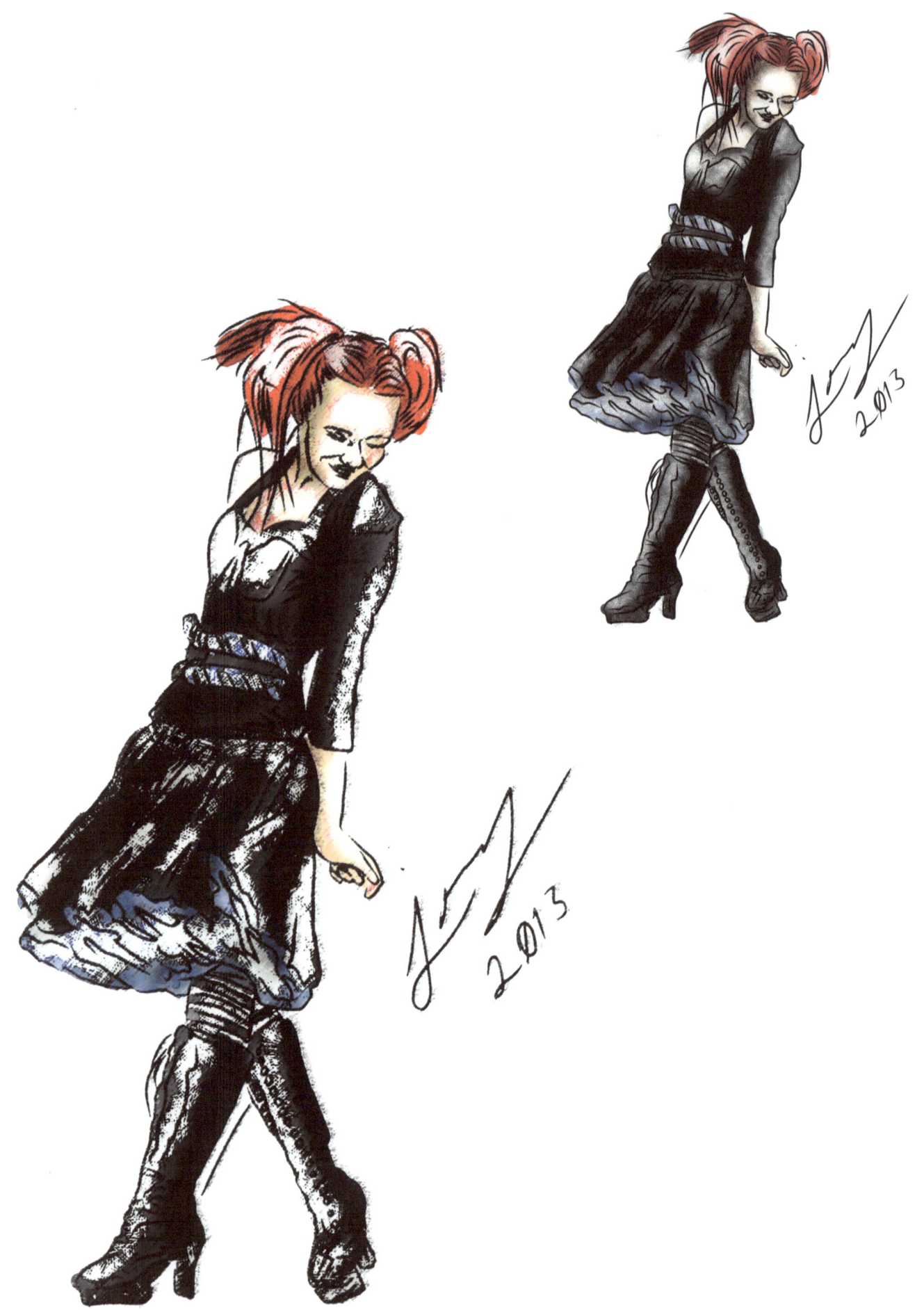

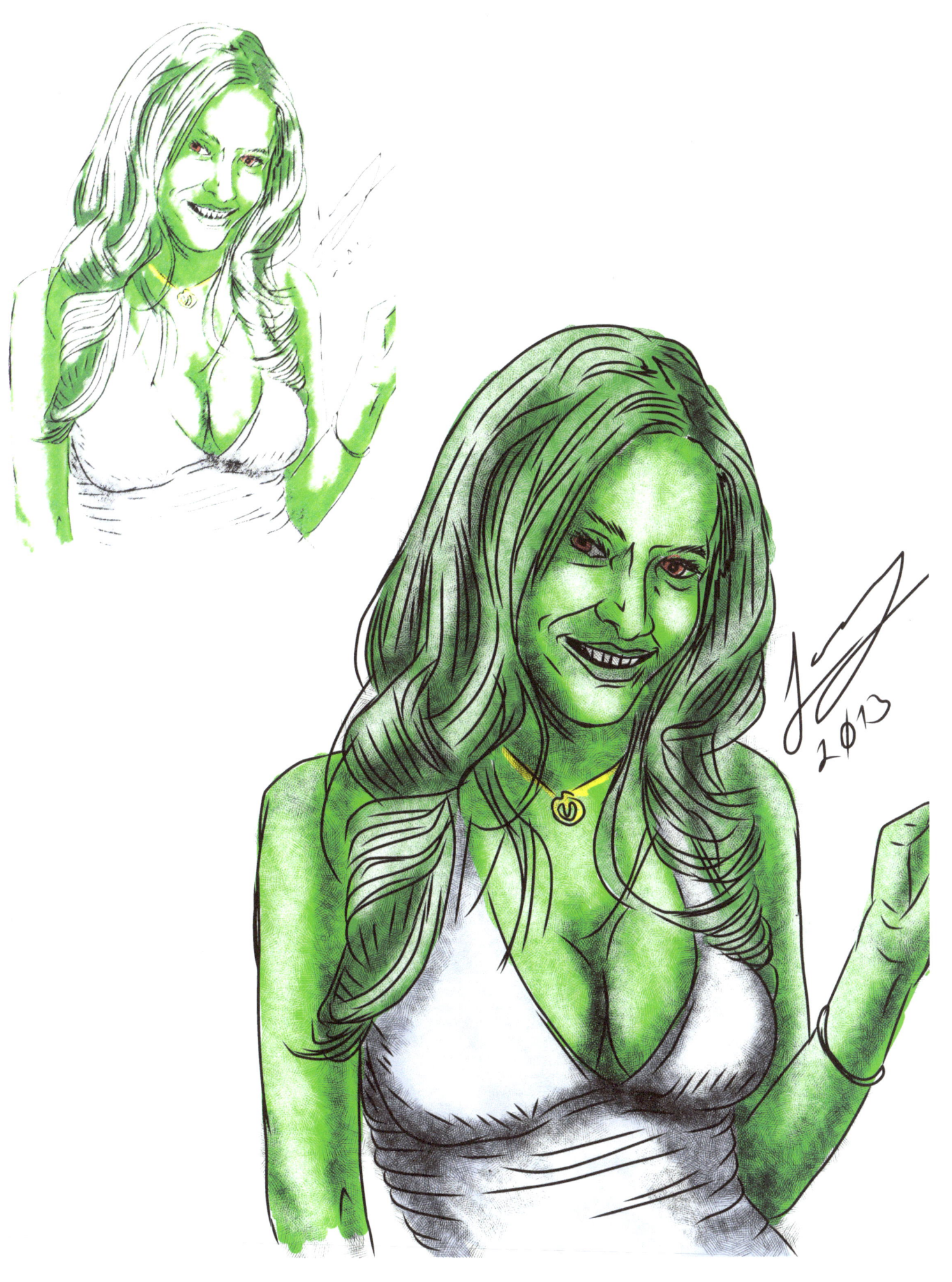

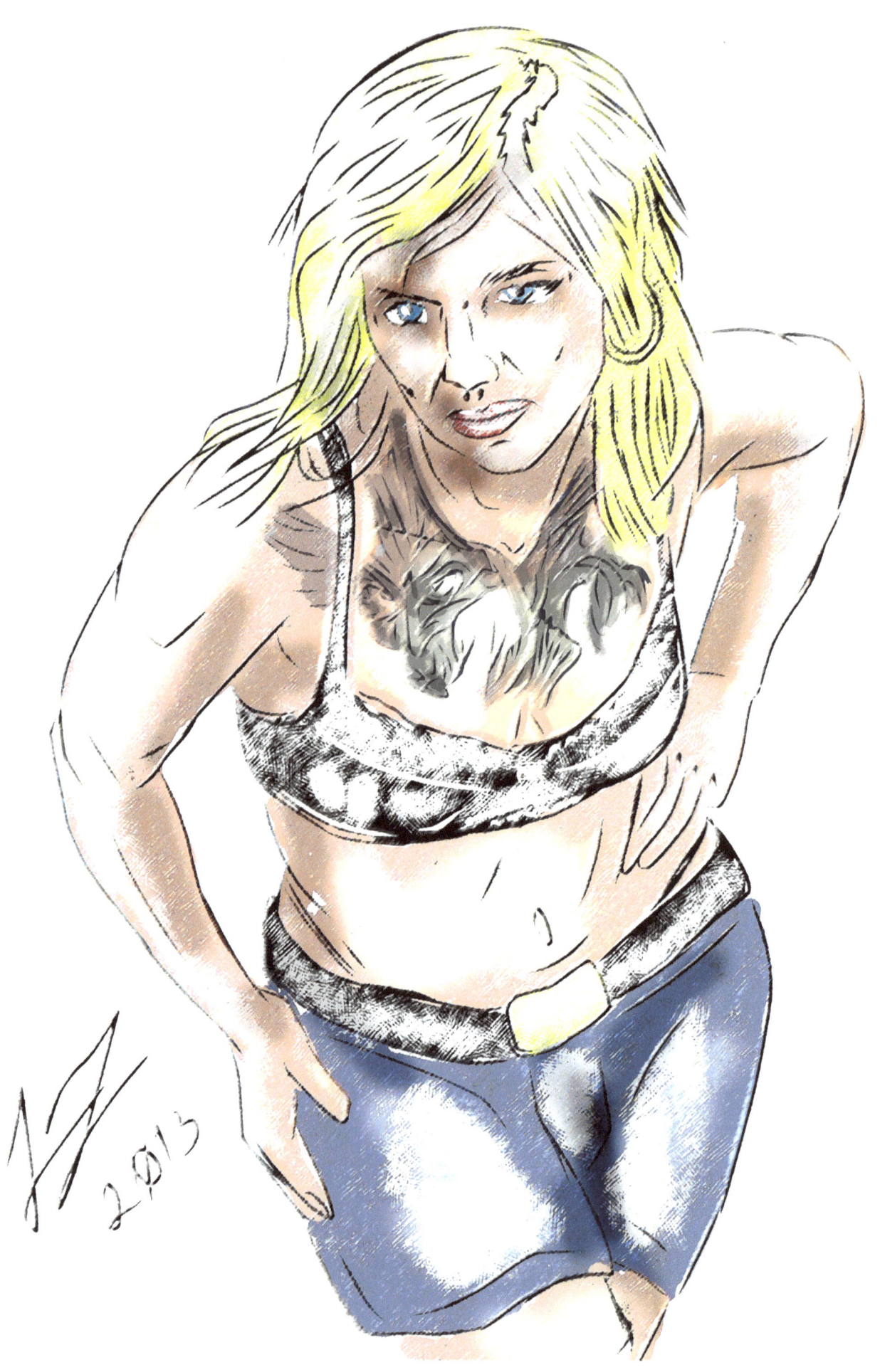

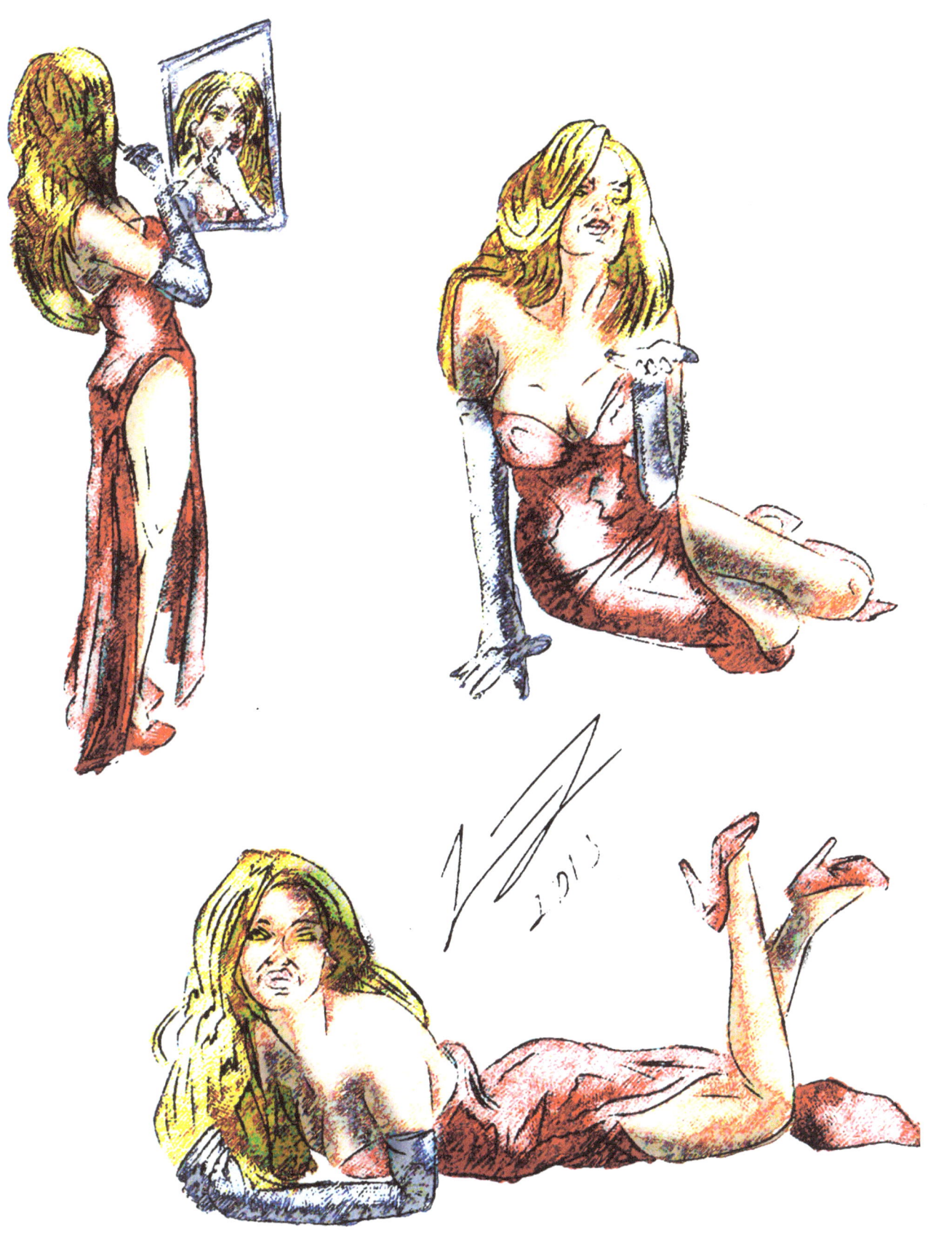

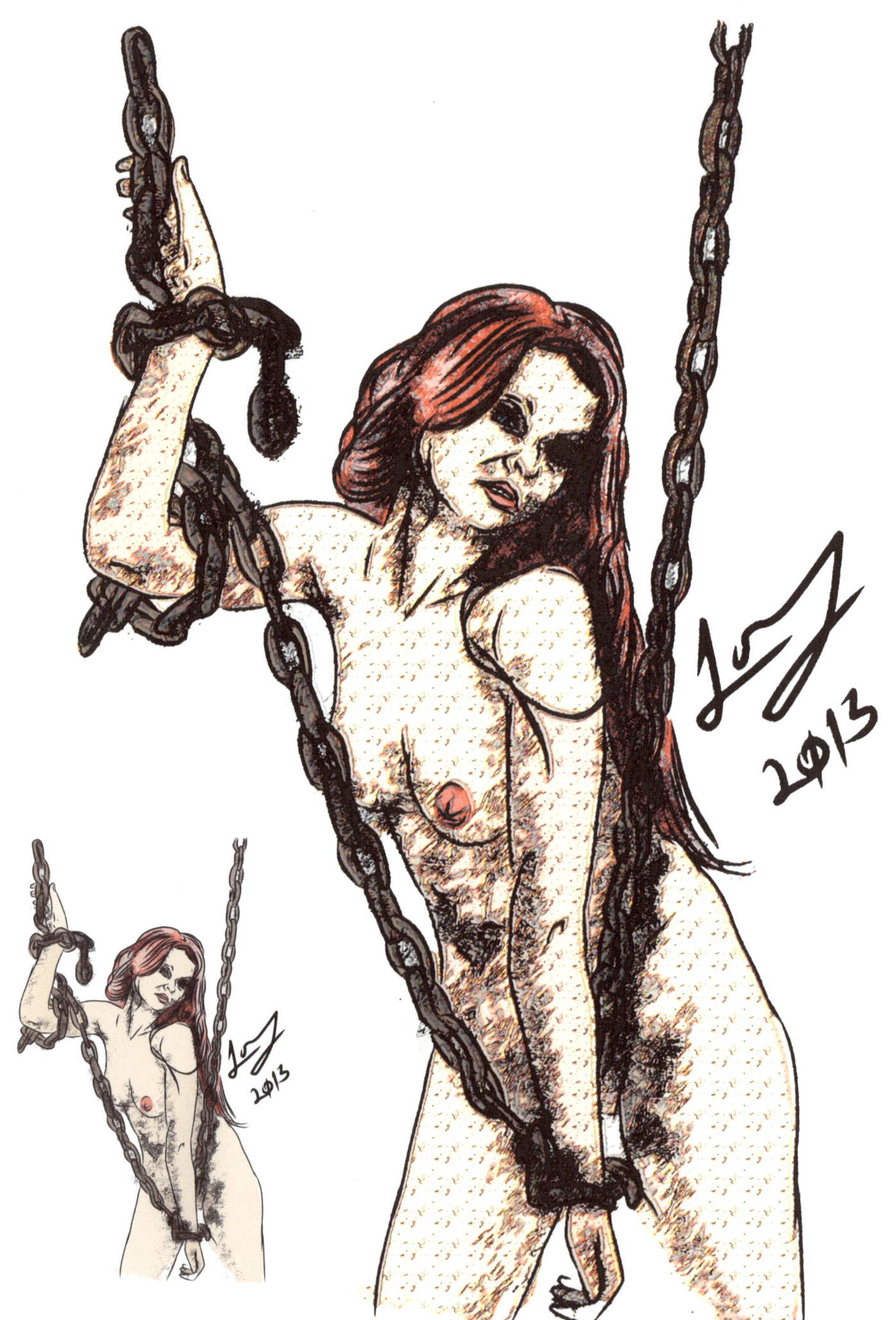

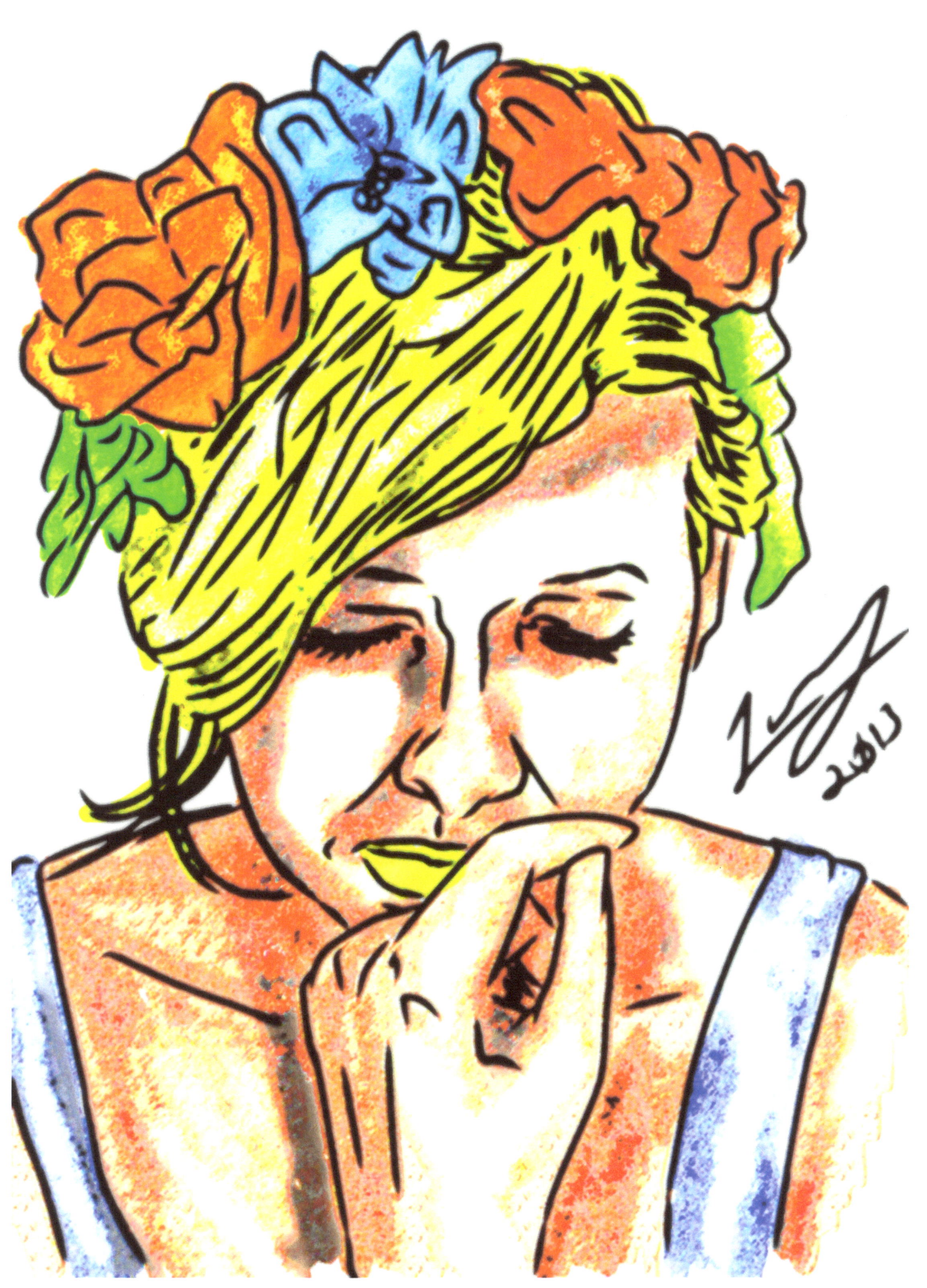

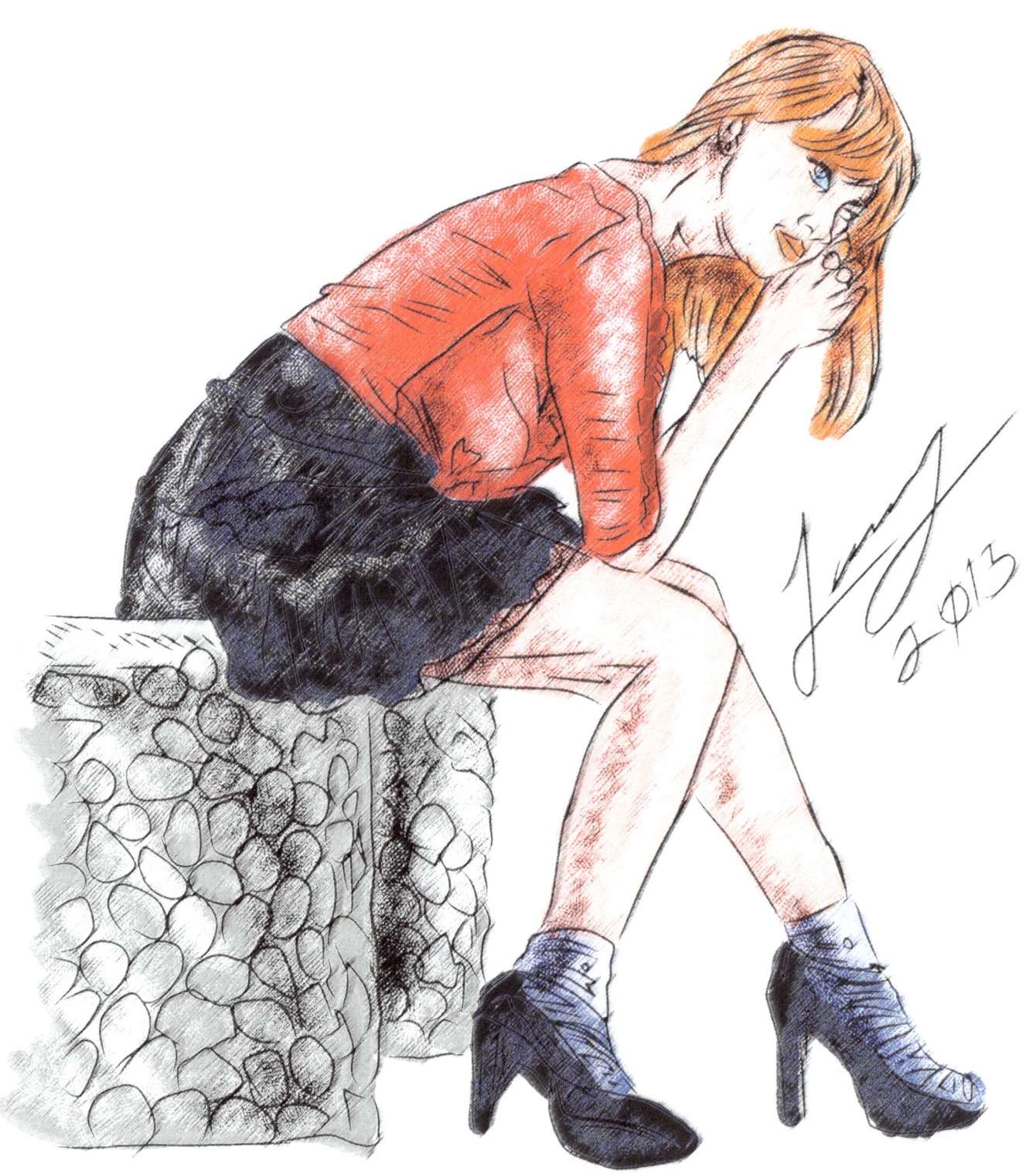

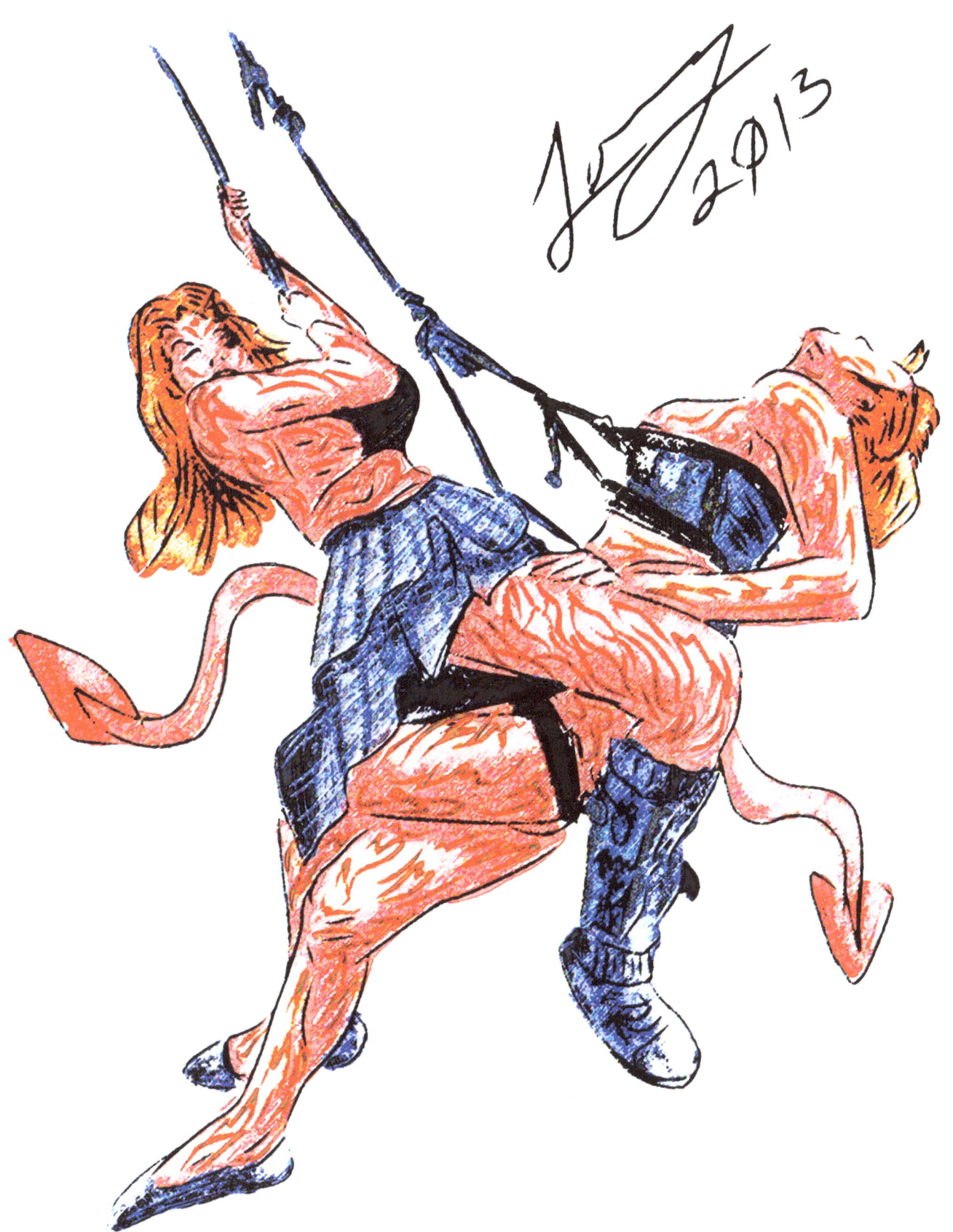

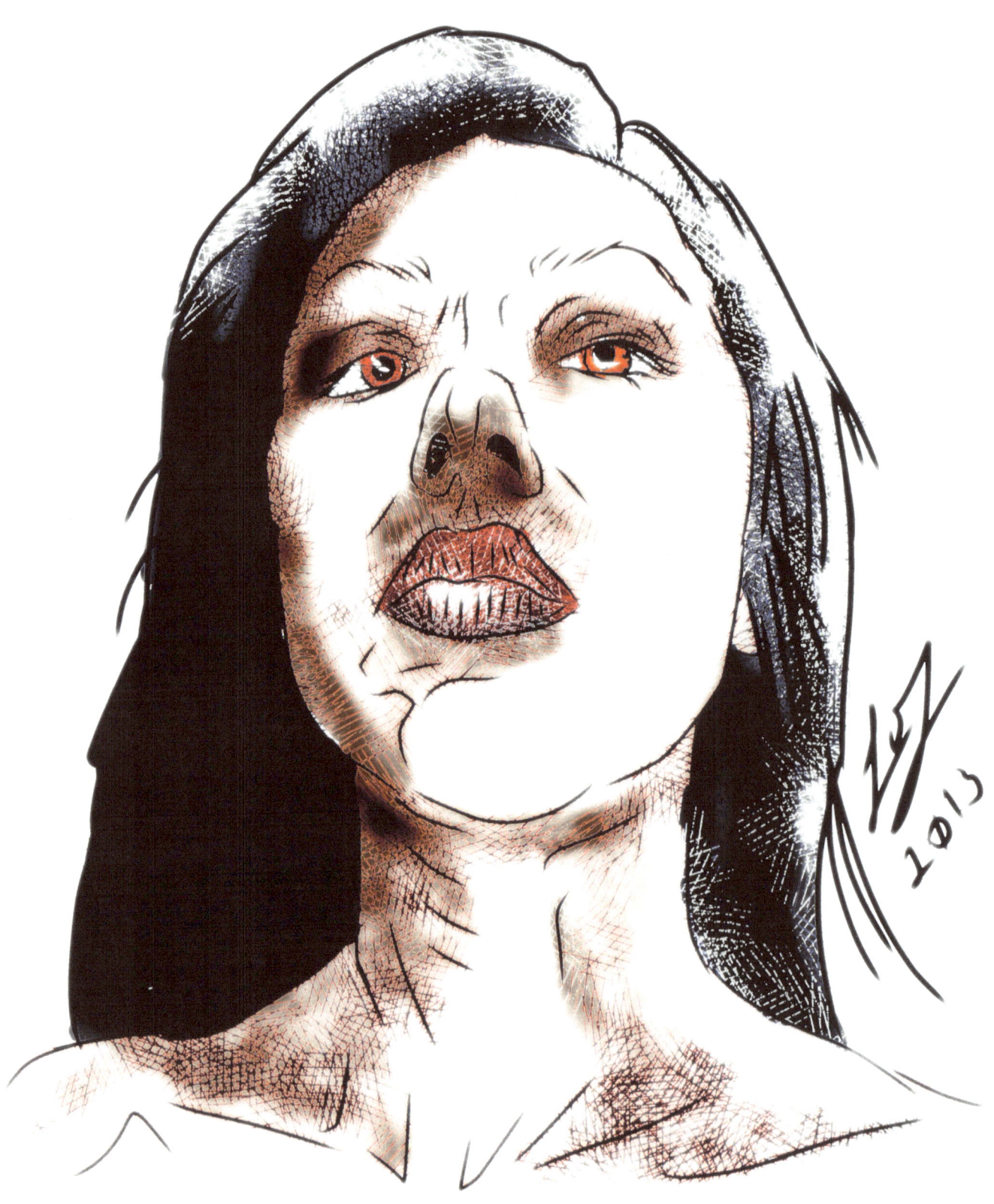

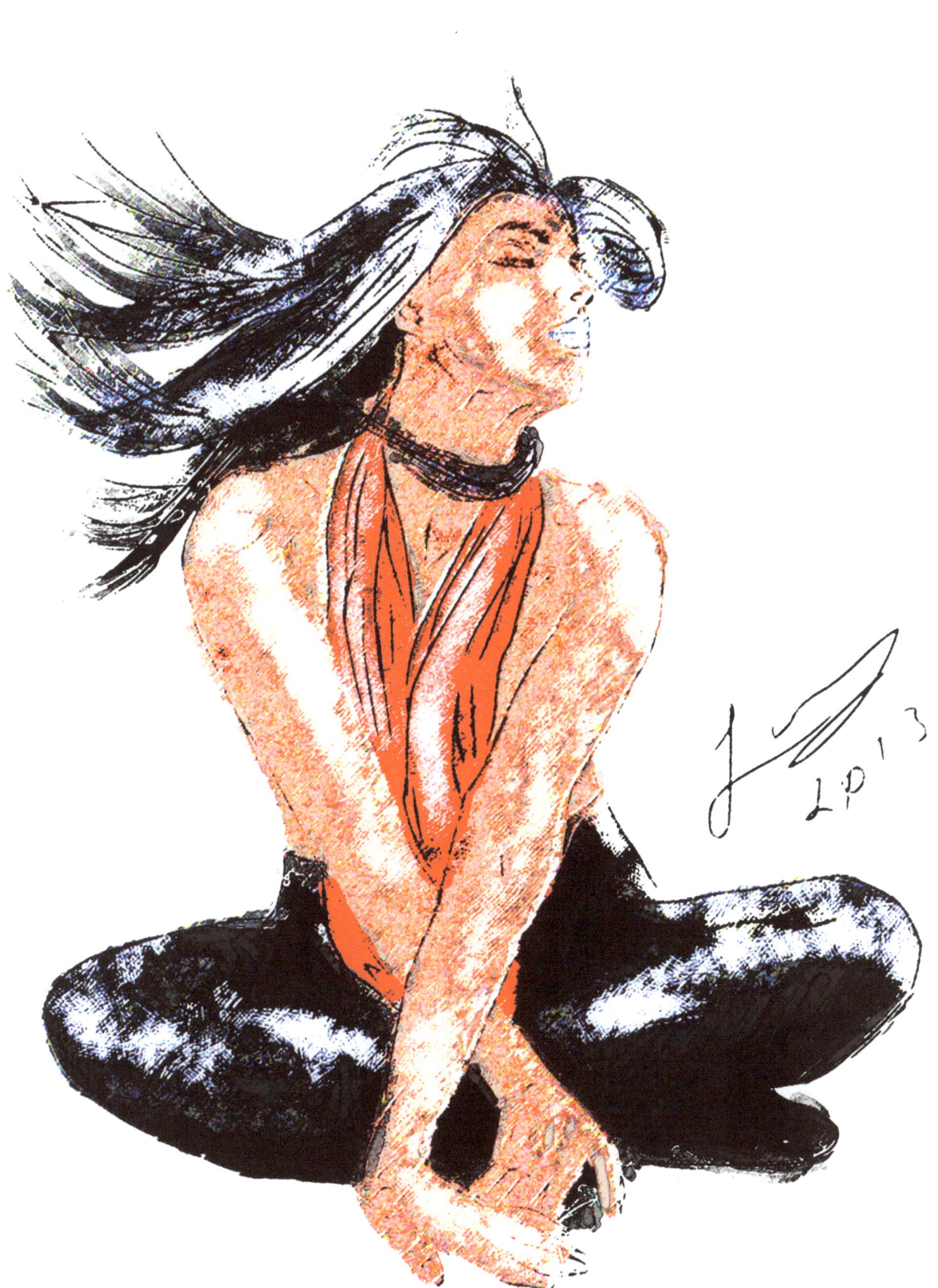

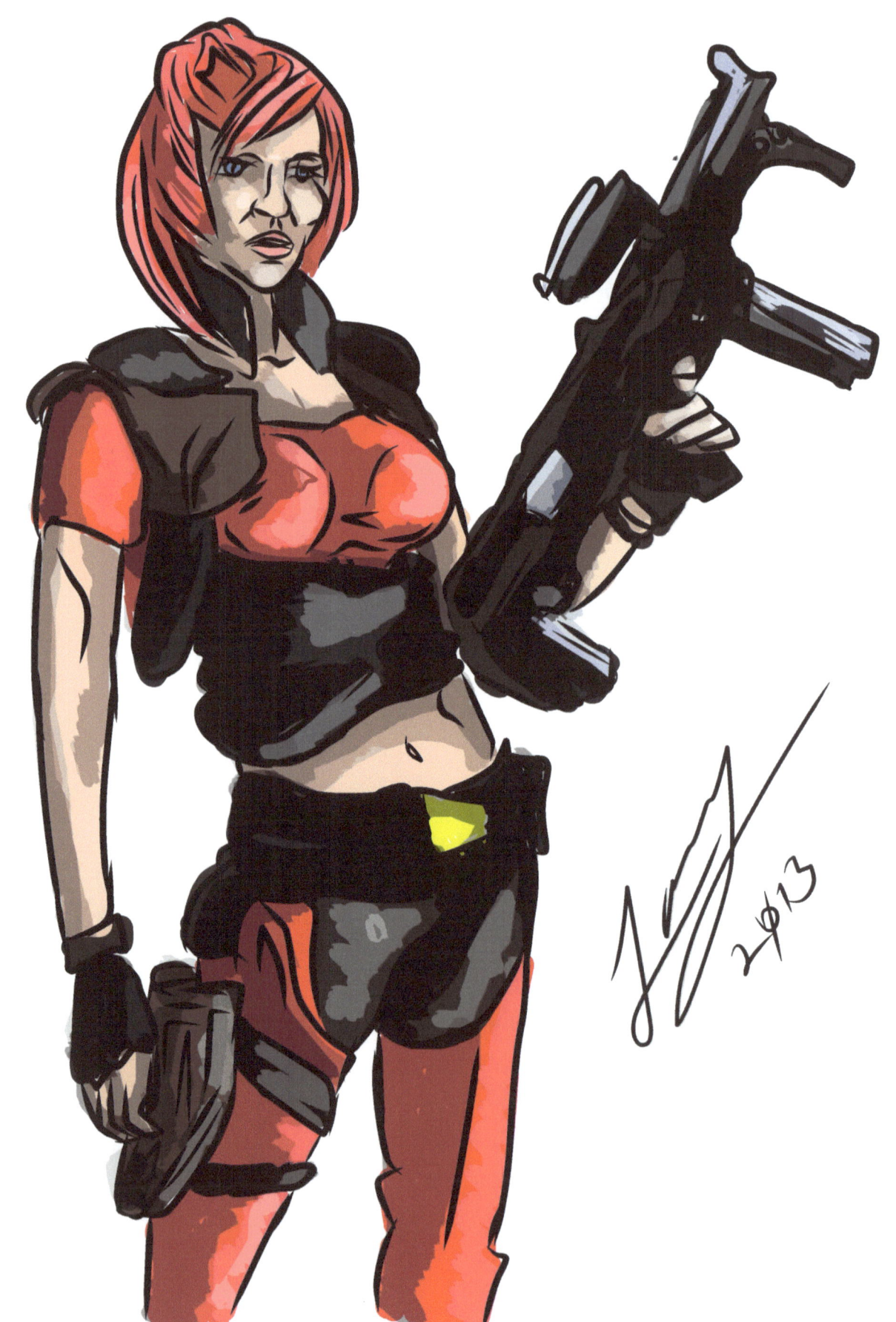

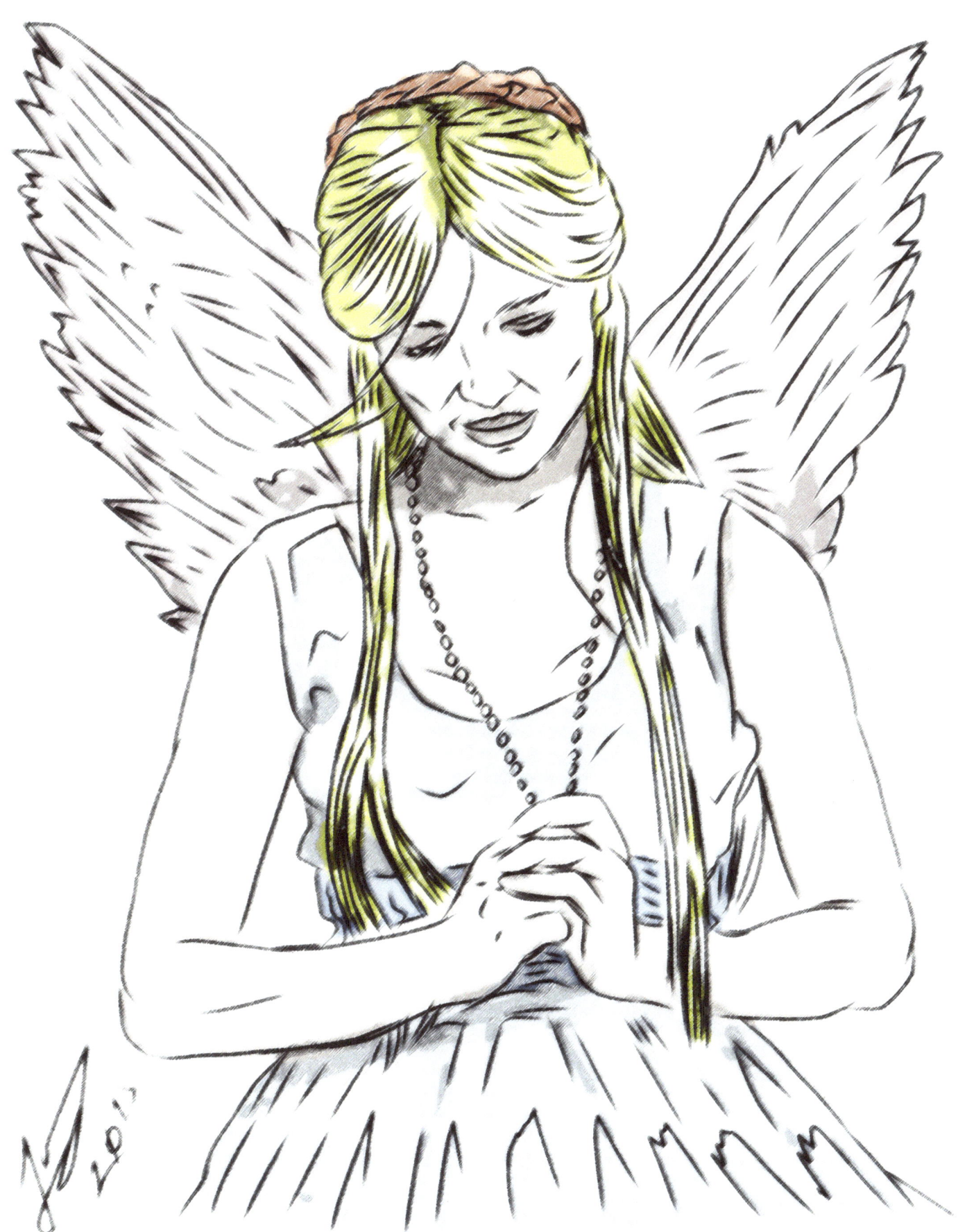

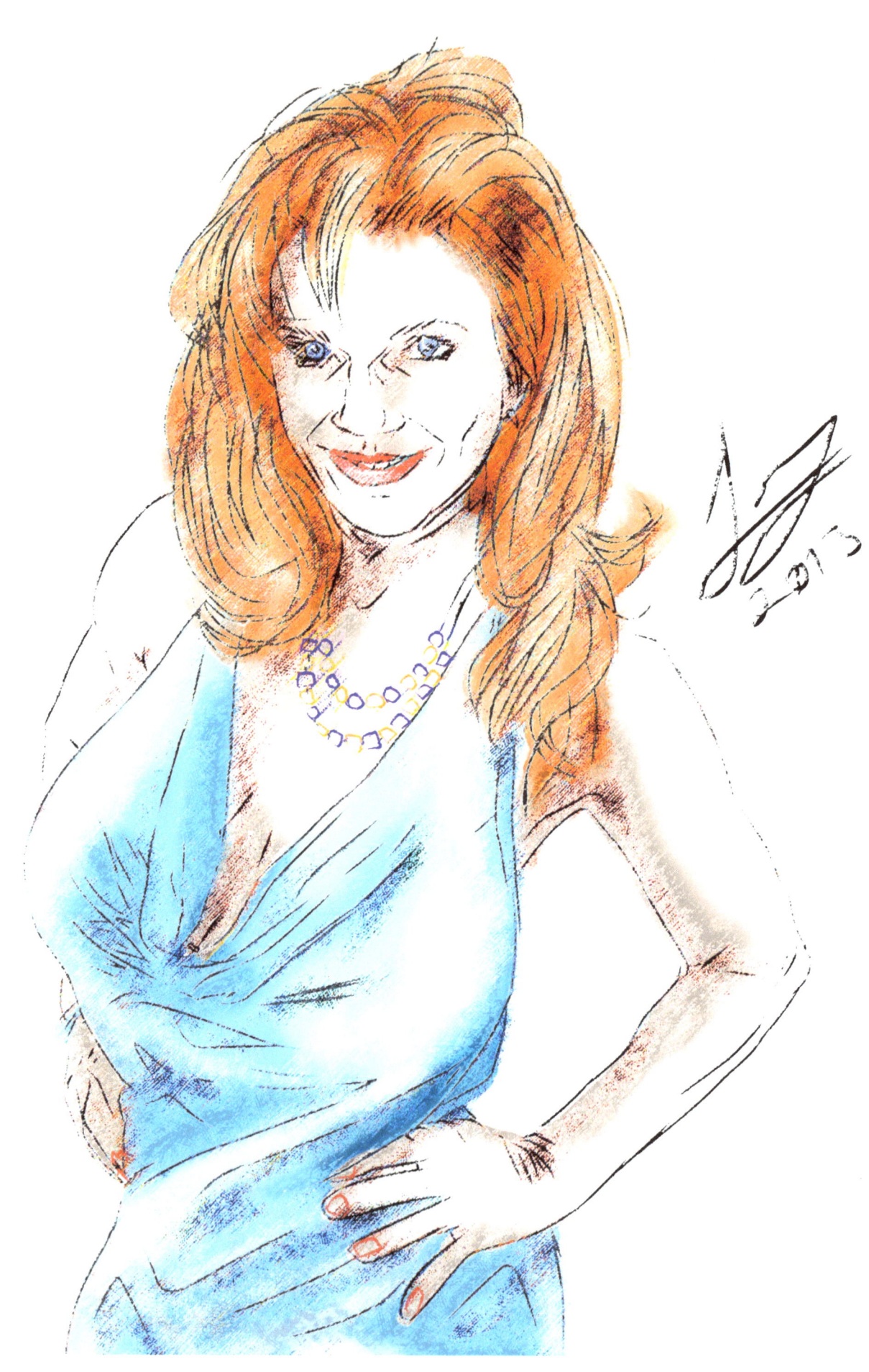

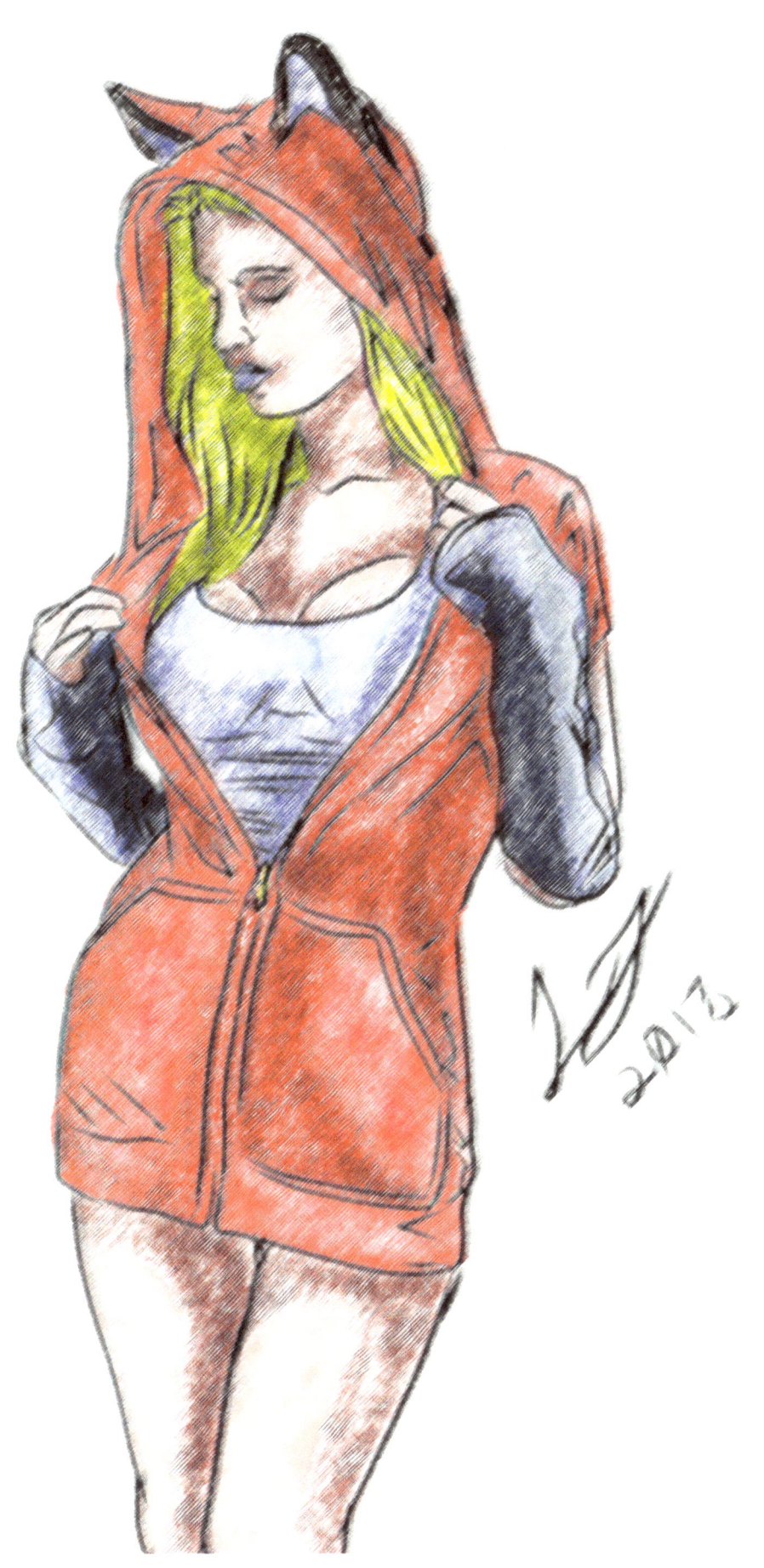

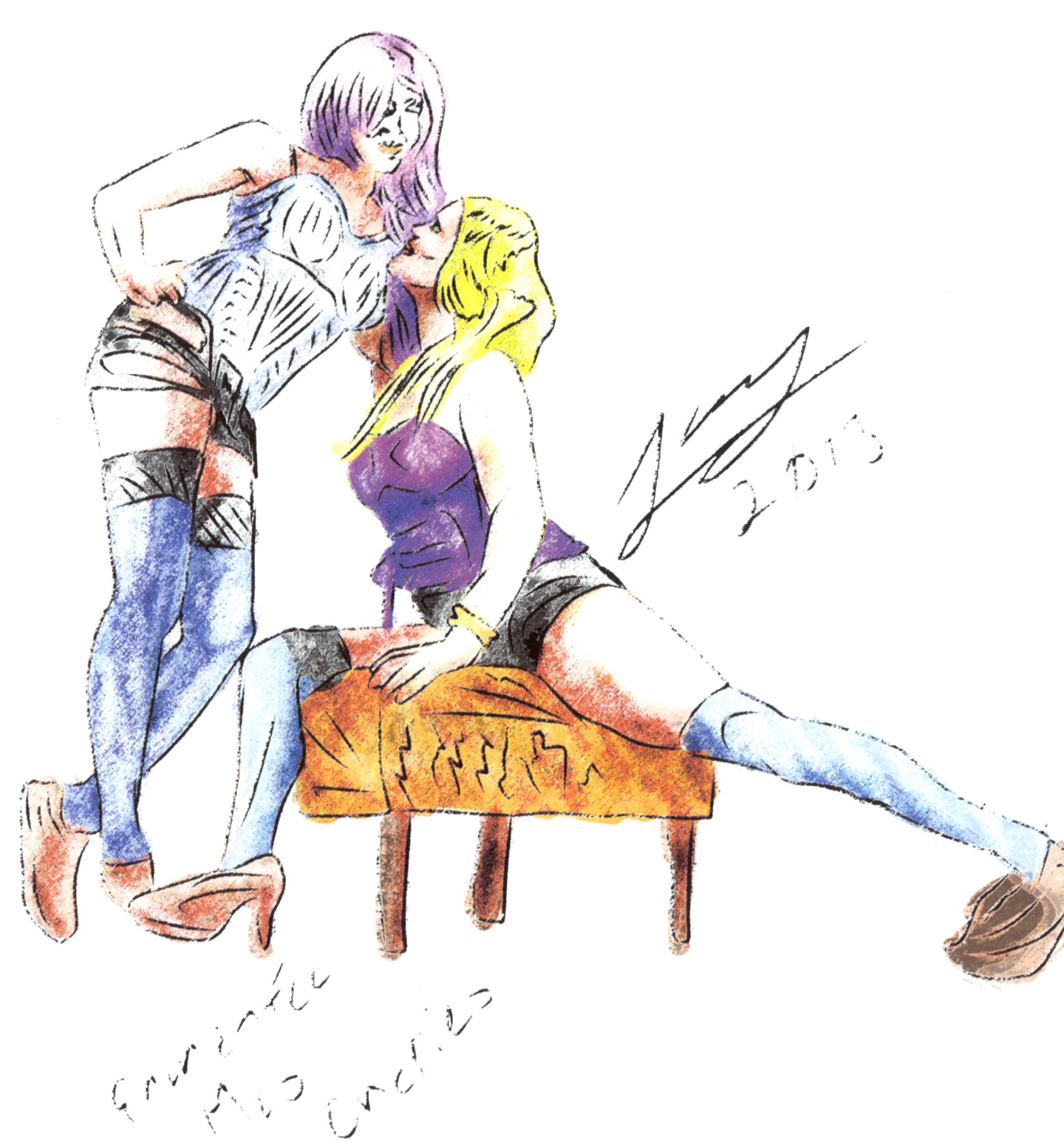

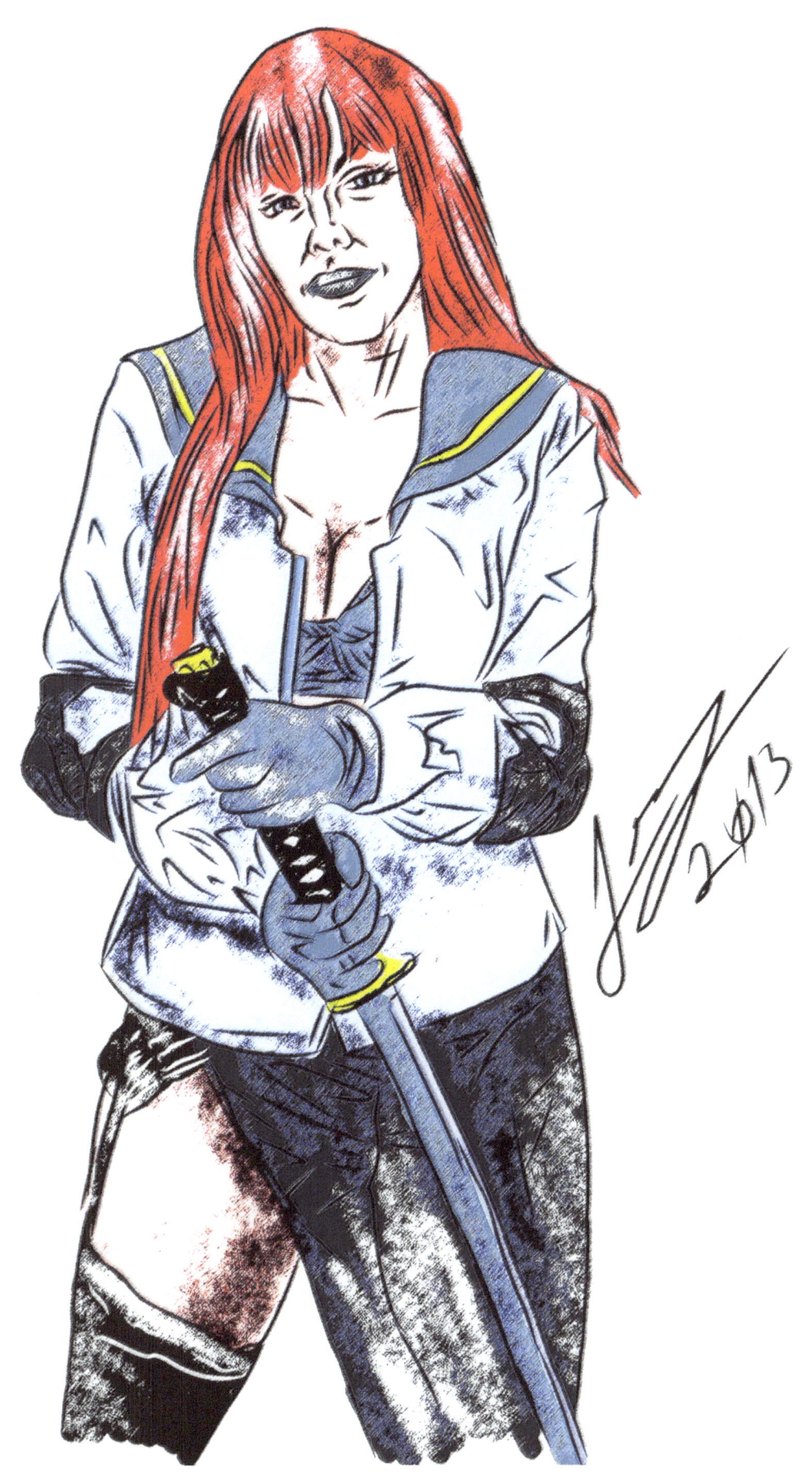

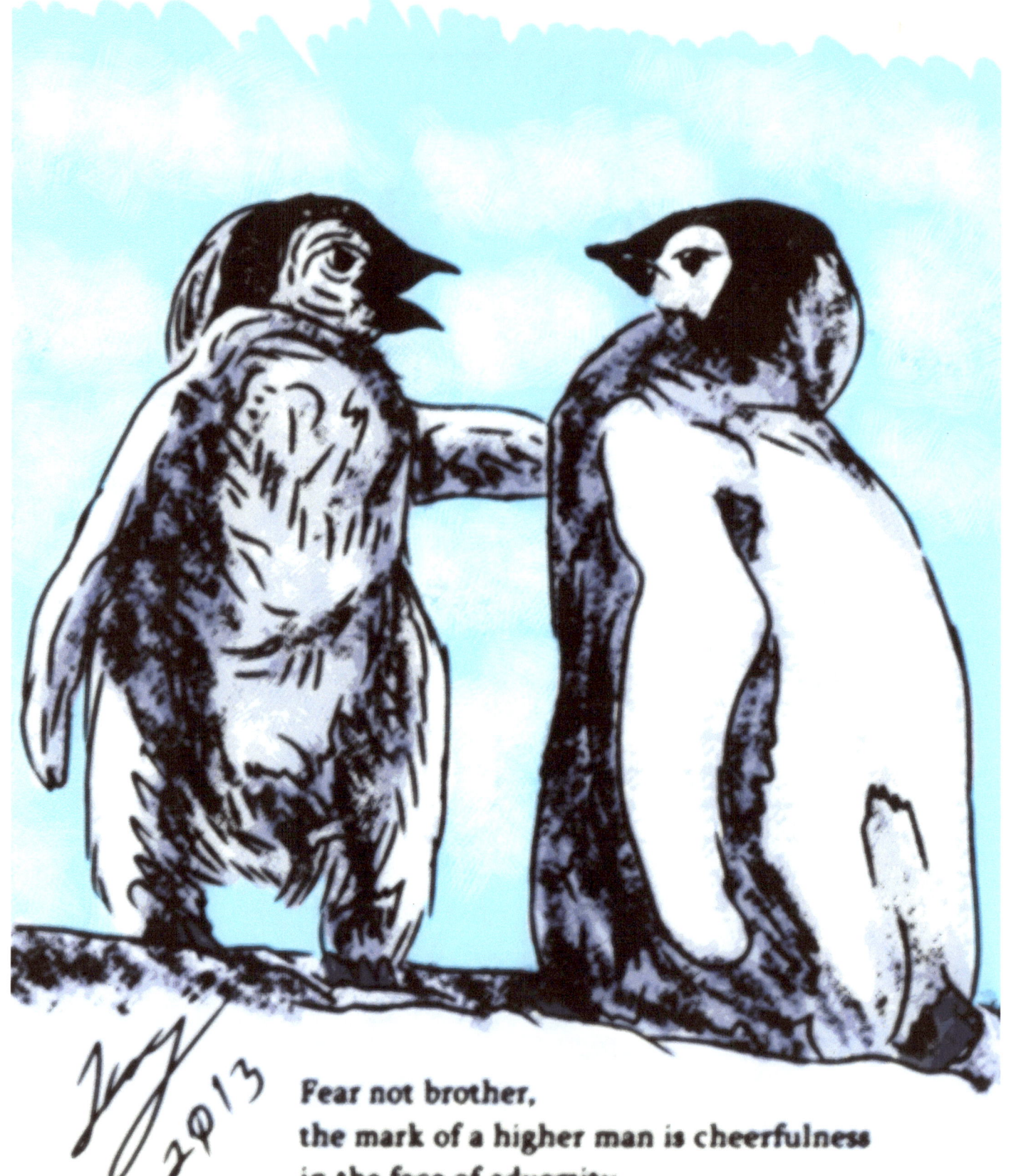

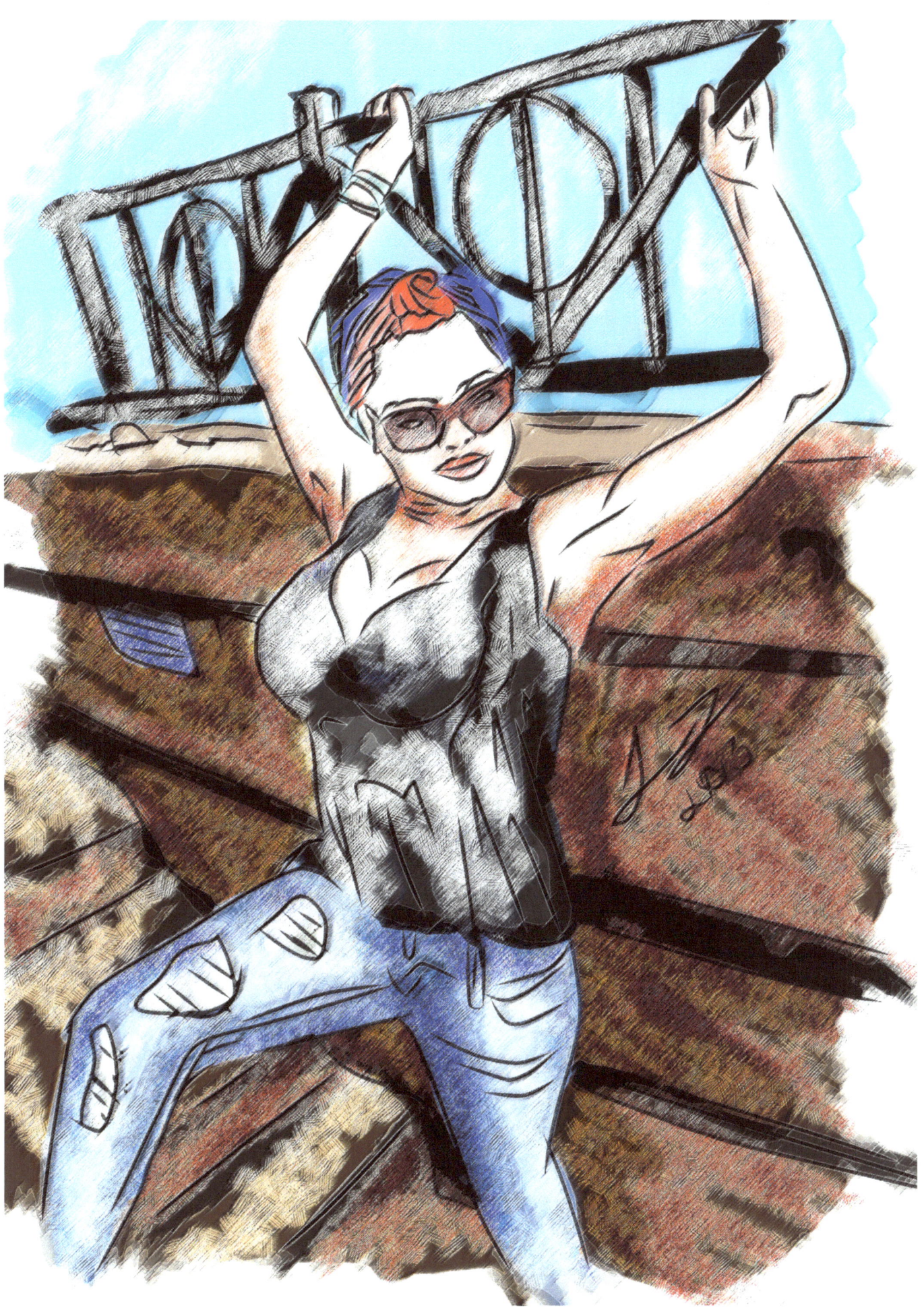

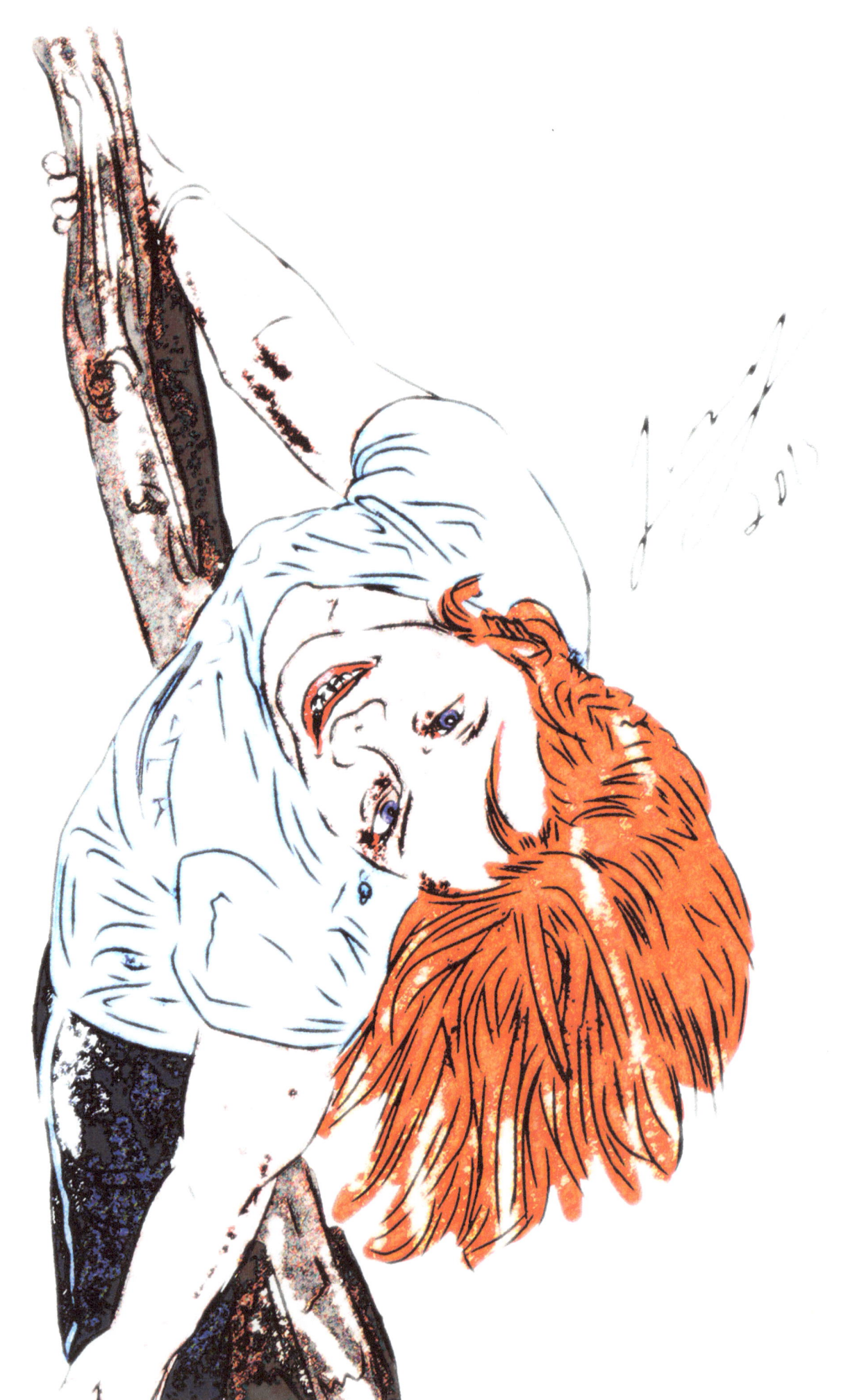

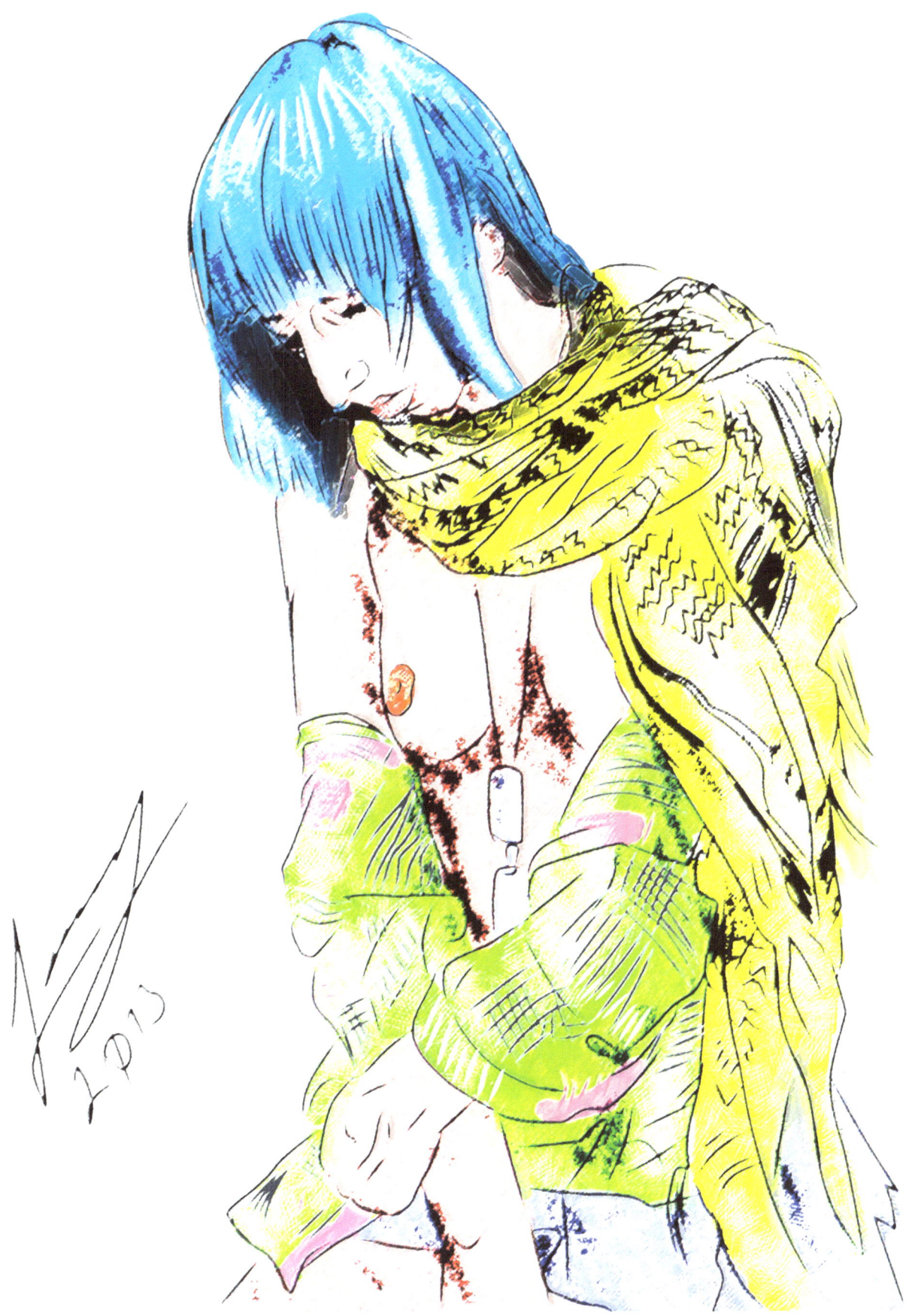

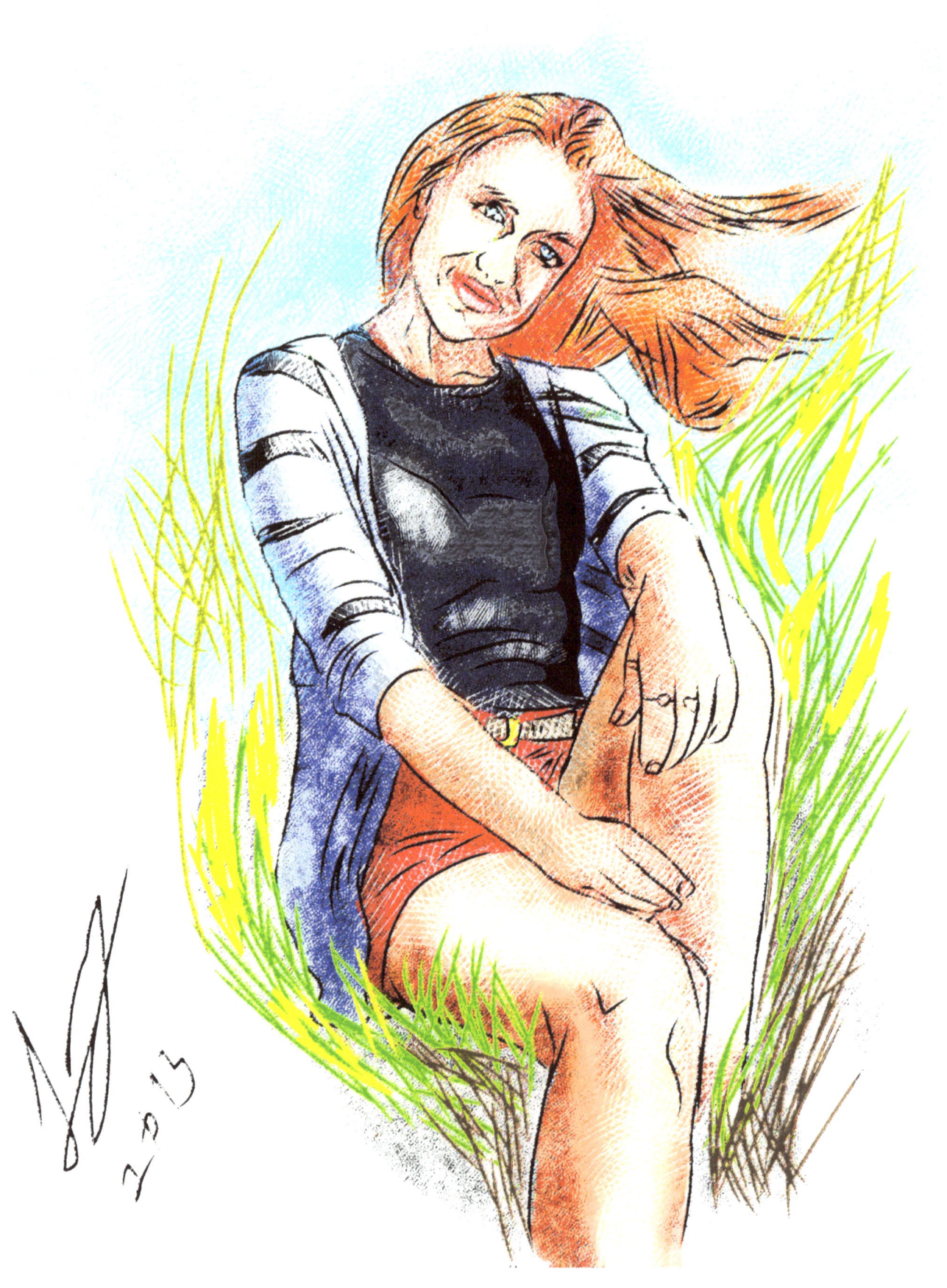

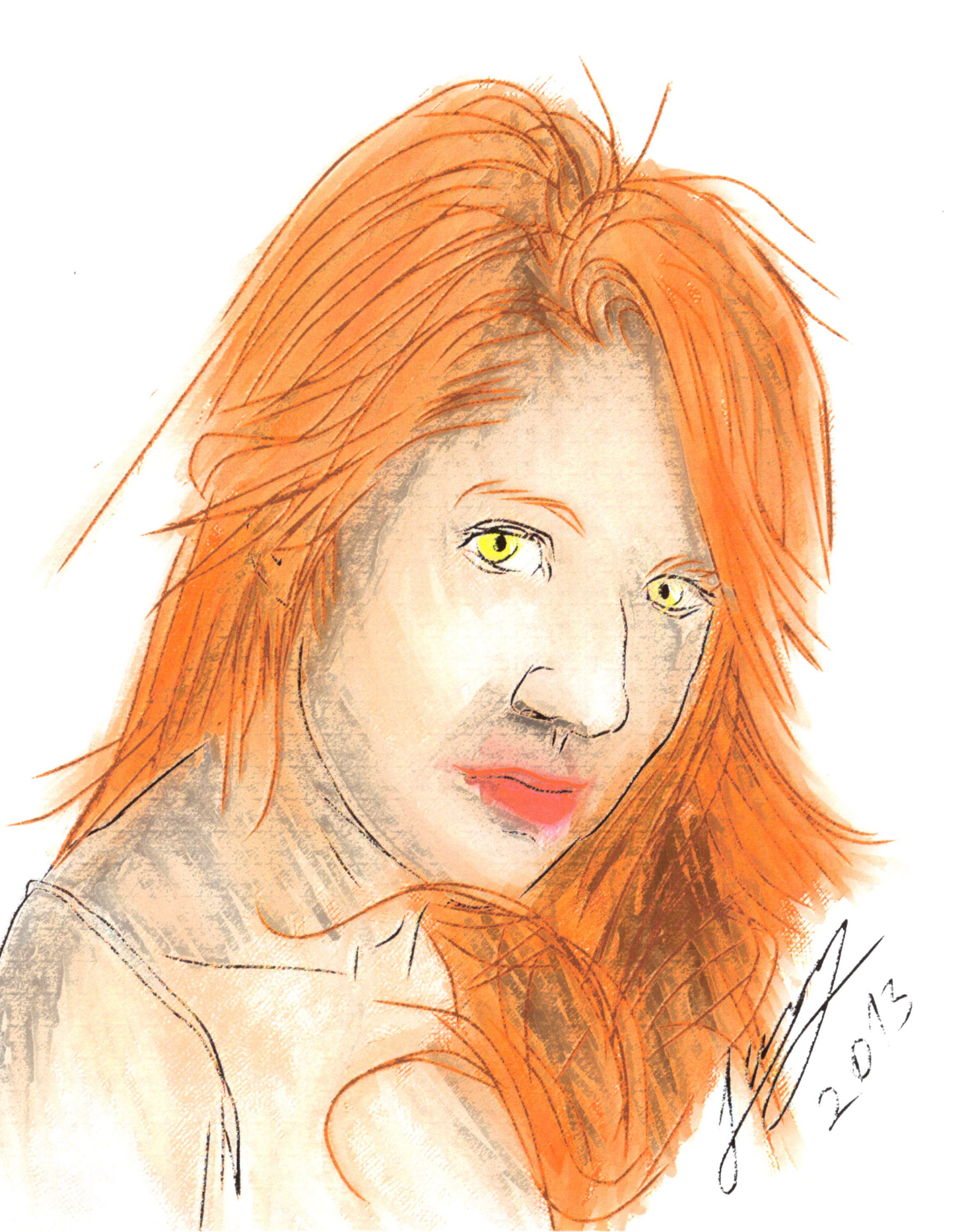

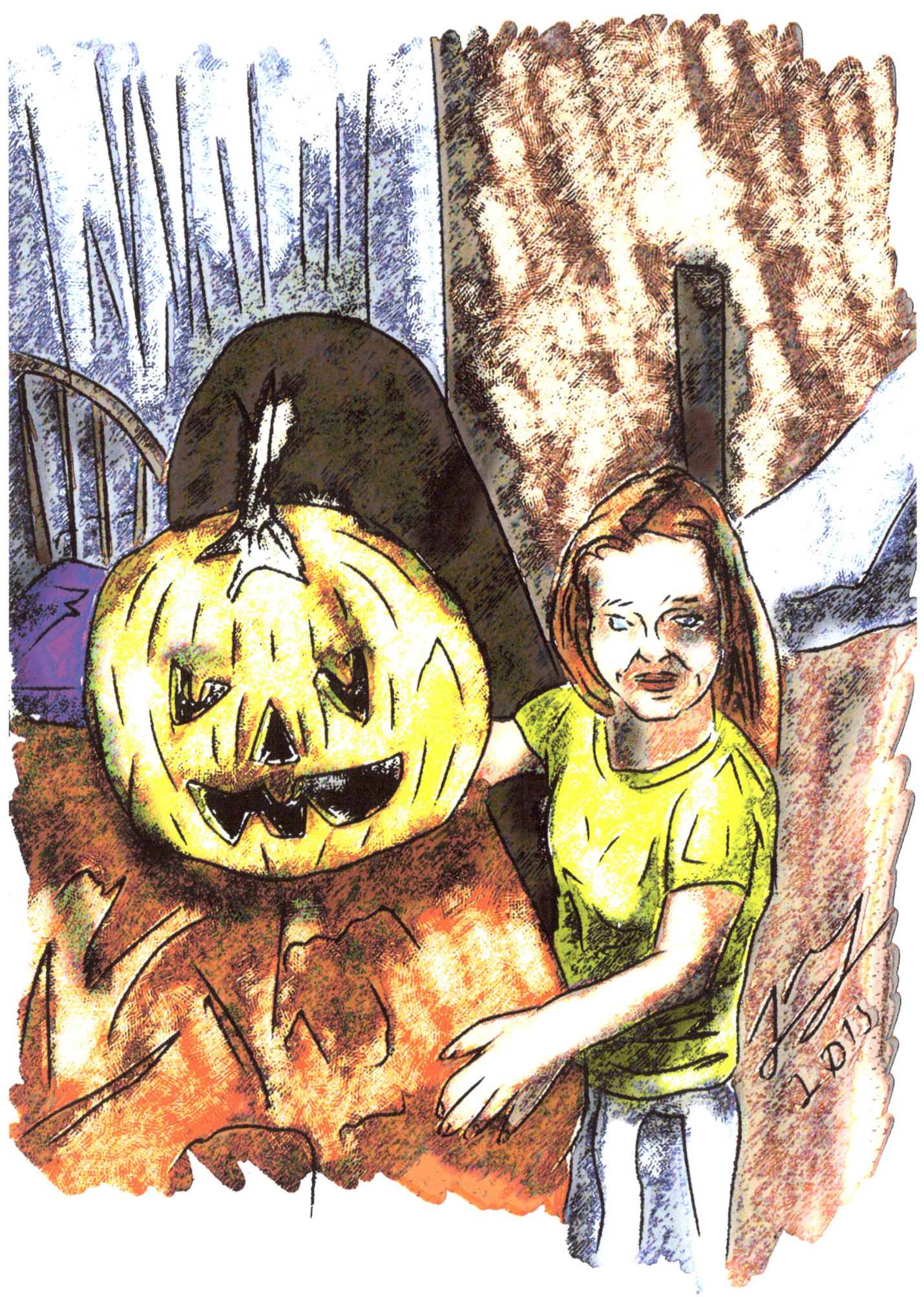

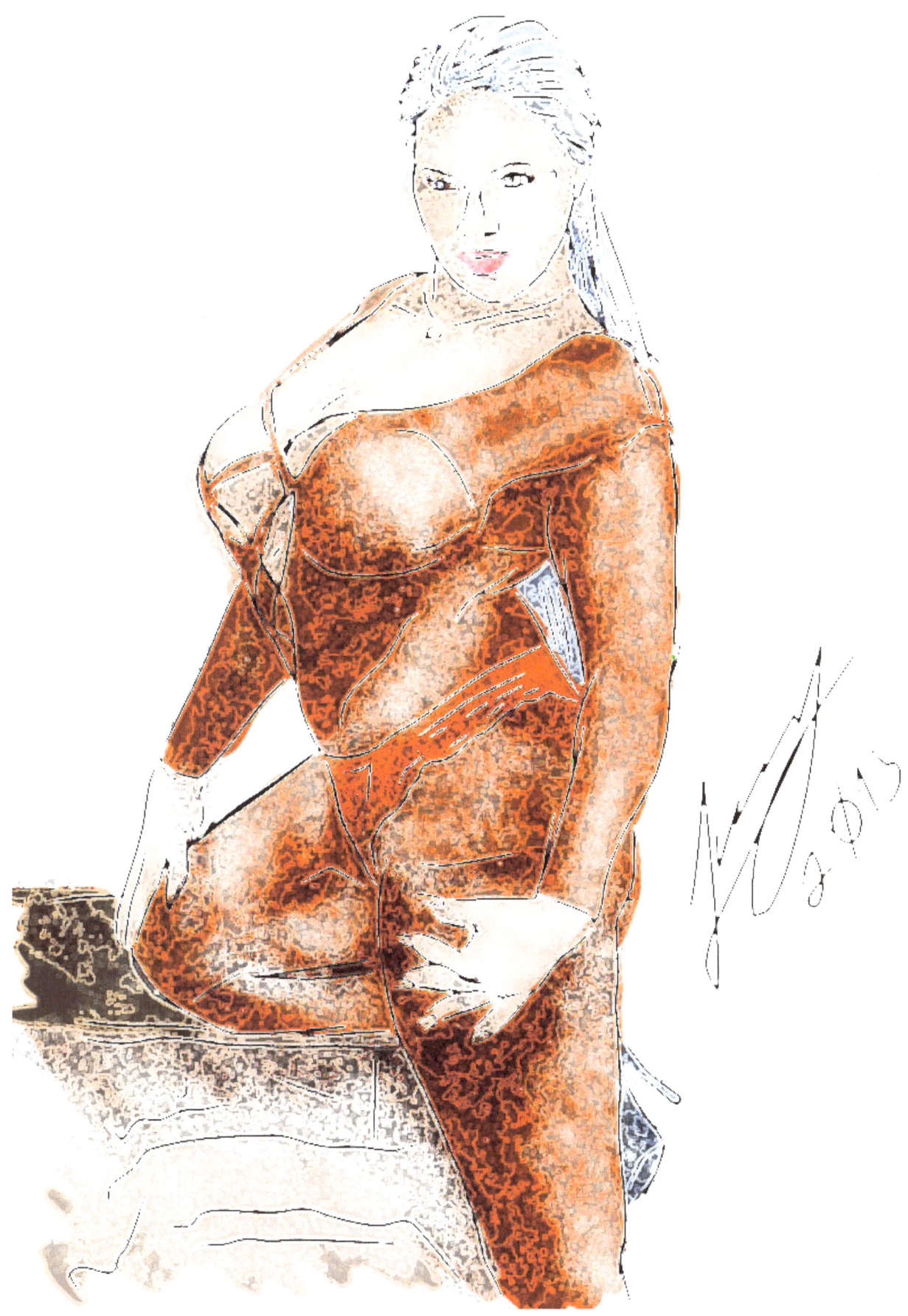

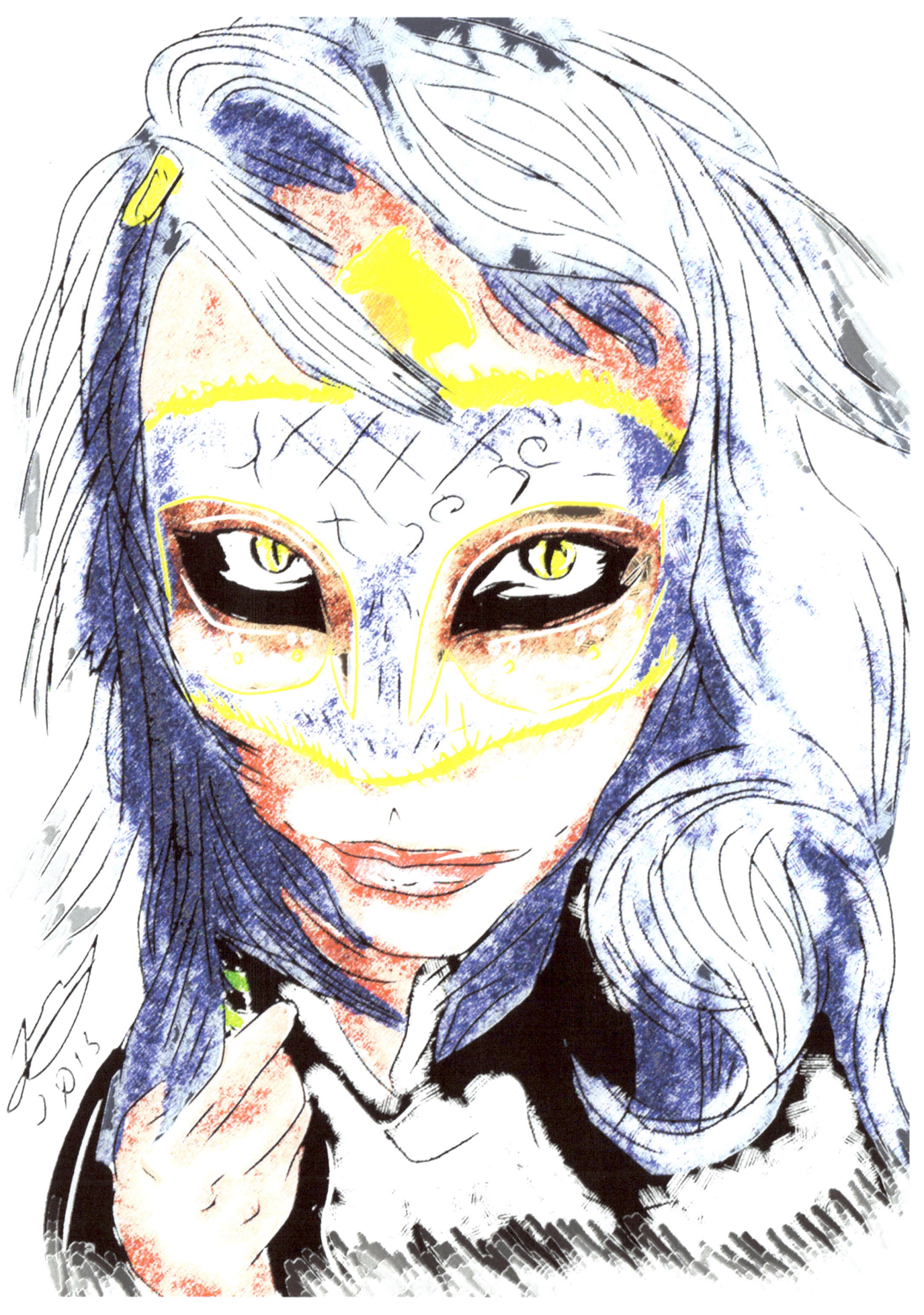

The Mad Hattress

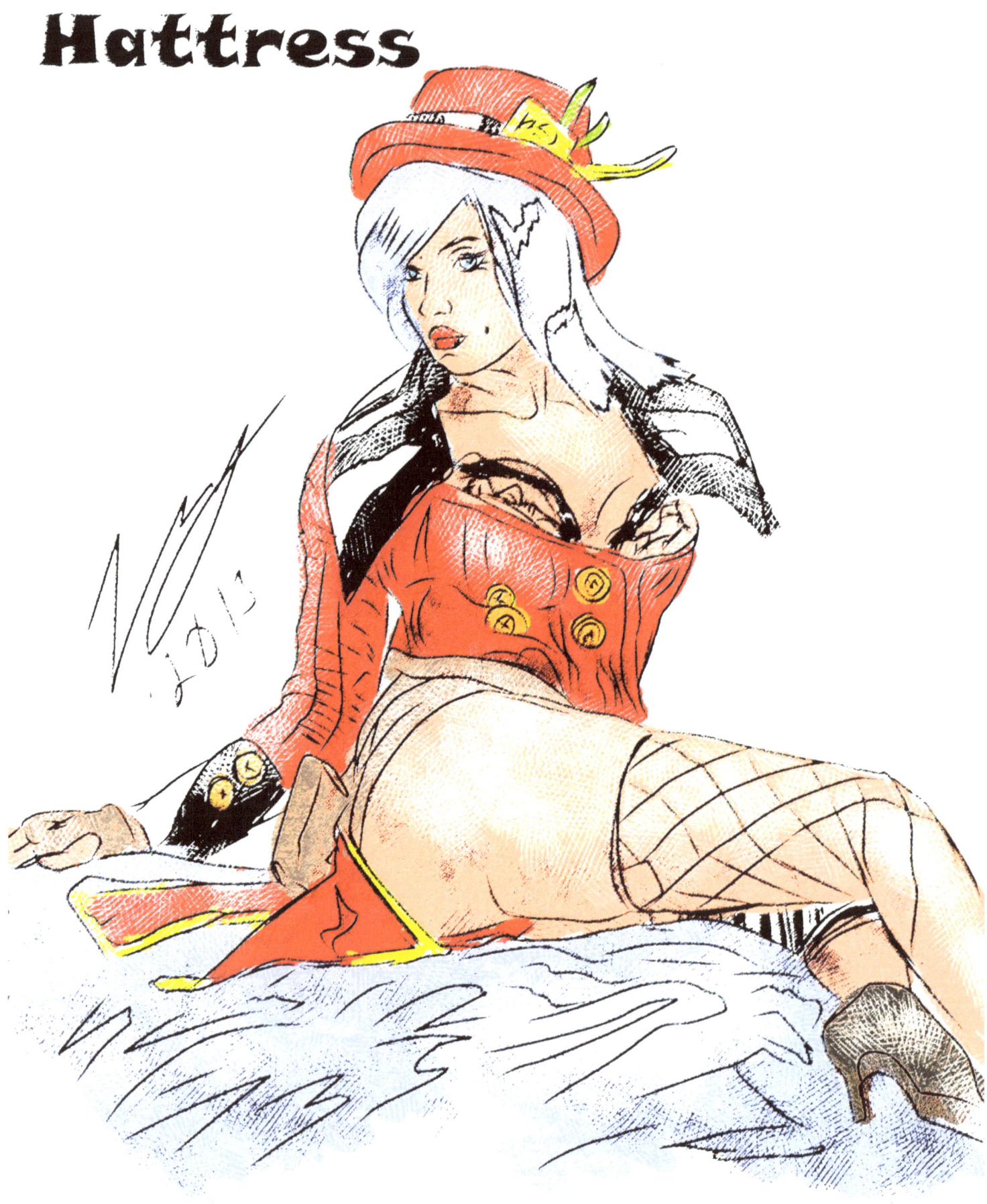

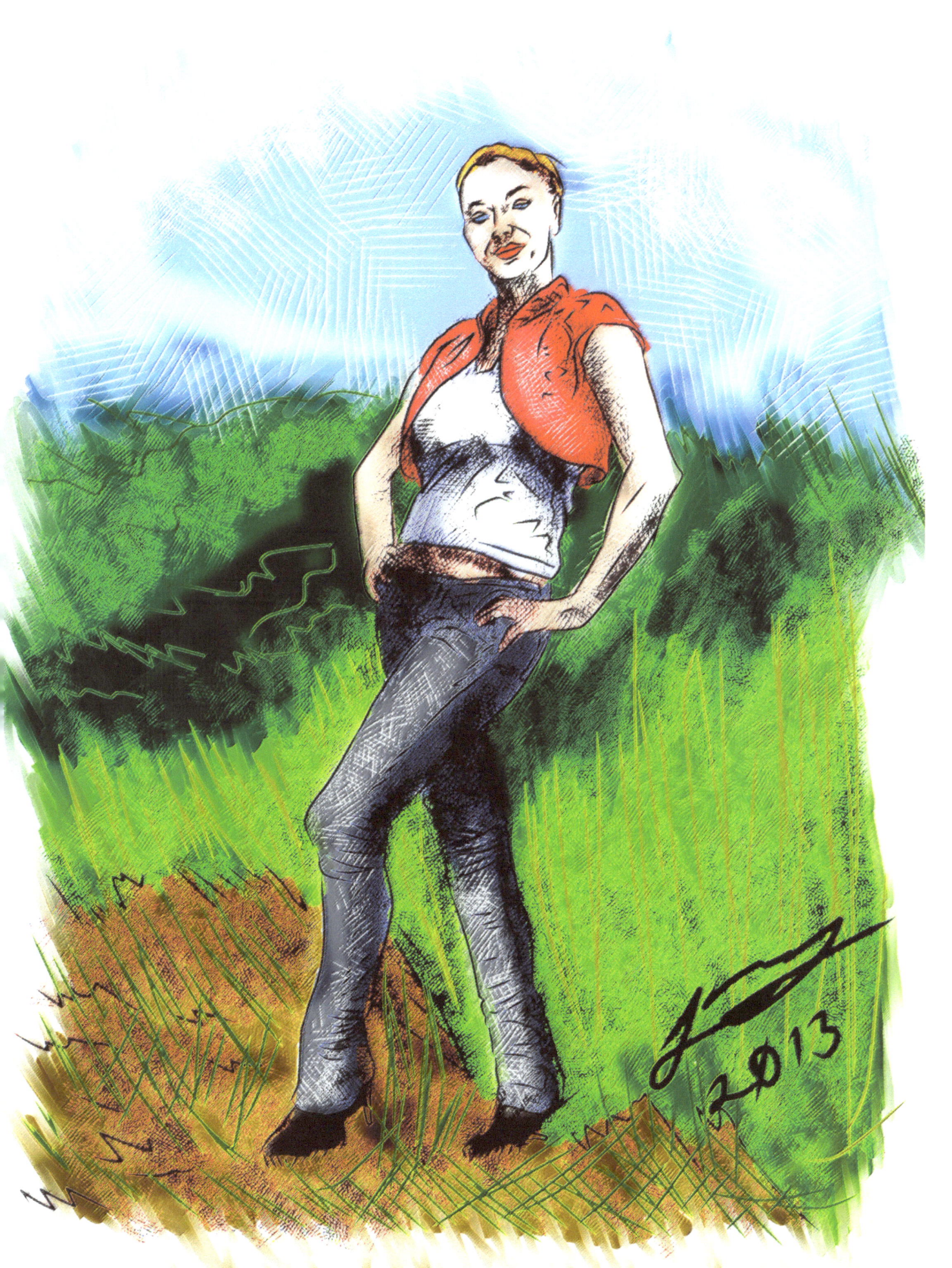

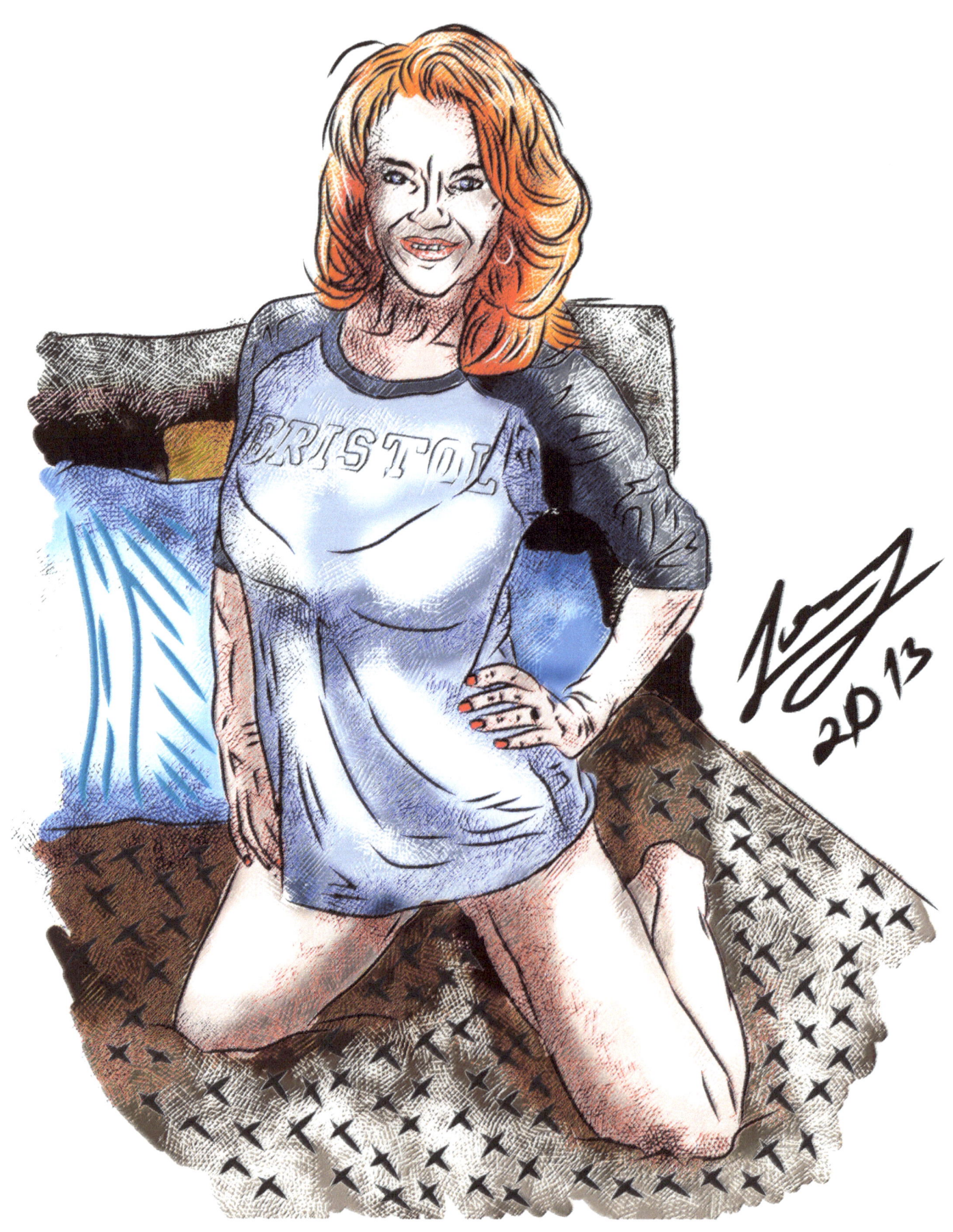

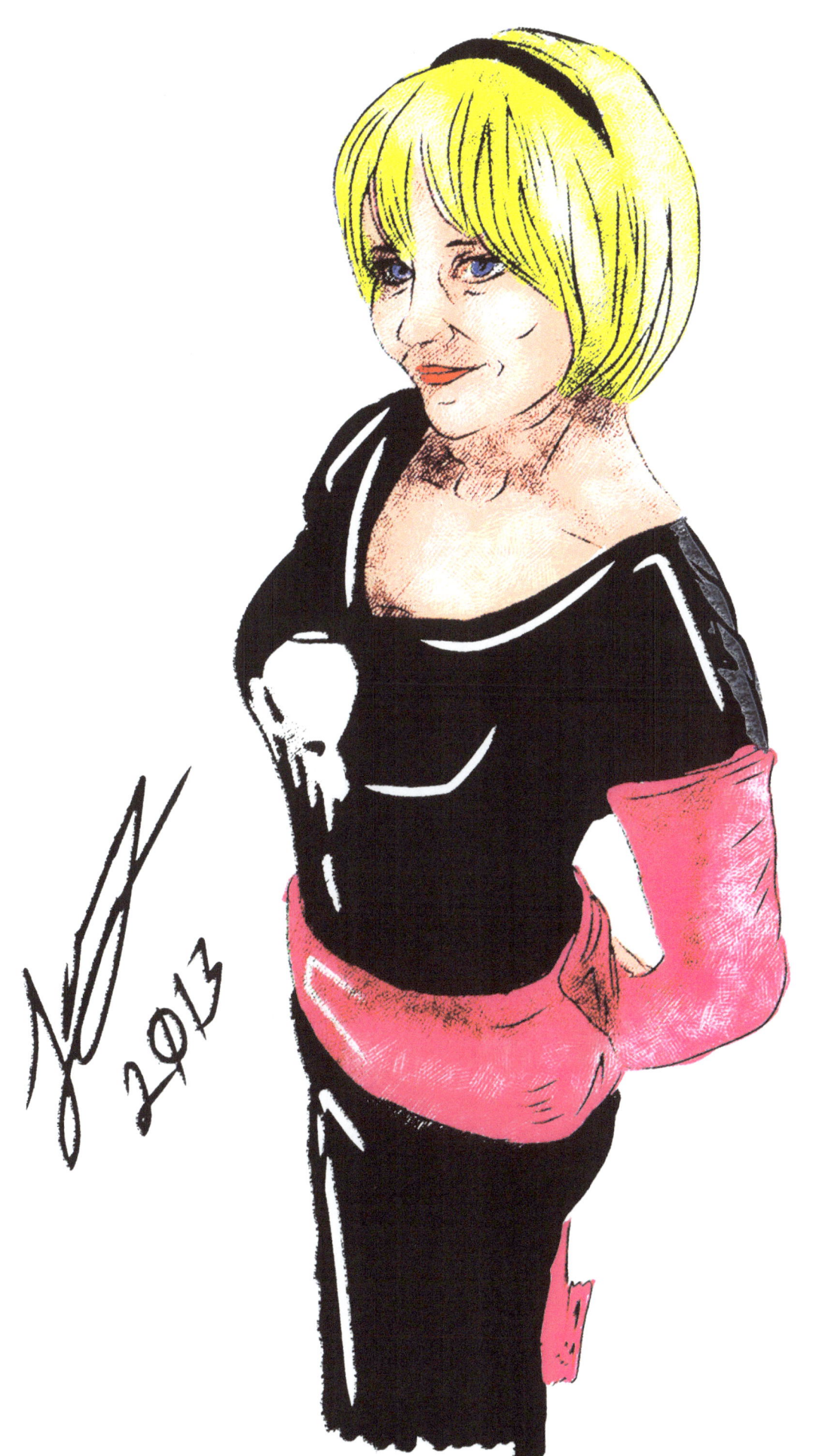

Art by Benjamin Long

Art is protected by US Copyright law, all celebrity or movie images or celebrities or public figures are satire or parody under fair use clause.. Permission must be obtained to use any artwork unless it is under fair use guidelines.

Point of Contact:

Skype: whitewolfheathen

E-Mail: wiking88142001@yahoo.com

Thank you for enjoying this portfolio...

www.ingramcontent.com/pod-product-compliance
Lightning Source LLC
Chambersburg PA
CBHW050355180526
45159CB00005B/2024